Contents

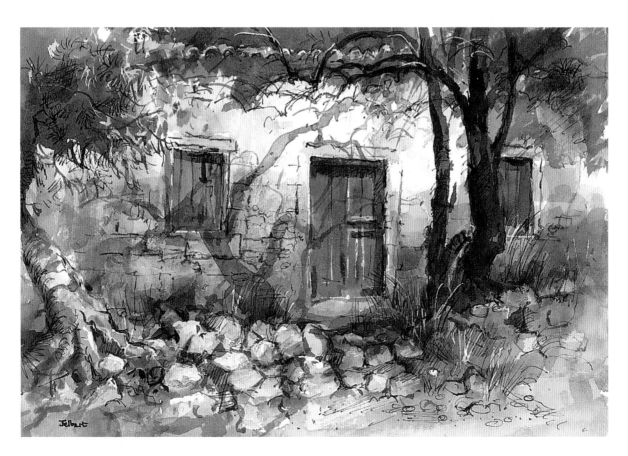

Portrait of an Artist

Wendy Jelbert was born in Redhill, Surrey, into a theatrical and medical family. She was always interested in painting and had a pencil and brush in her hands from a very early age. Although art was always in the background, she did not take it up professionally until later in life. She partly trained as a nurse, changed to modelling in London, and then gained her Silver and Gold medals and Performer's Diploma from the Guildhall School of Music and Drama.

▲ Wendy Jelbert in her Hampshire studio.

Wendy returned to art when bringing up her children – two of whom are now professional painters. She studied abstract and fine art, sculpture, ceramics and printmaking at Southampton College of Art, then later trained as an art teacher and became deputy head of a local adult education centre at Wyvern School in Hampshire.

She now teaches in oils, watercolours, acrylics, pen and wash, drawing and mixed media in residential colleges throughout England and in Greece, Italy and France each year, as well as in her own village of Nether Wallop, Hampshire, the location used by BBC TV to film the 'Miss Marples' series. She also demonstrates at the 'Art in Action' exhibitions and 'Artists' Materials' shows, and lectures and demonstrates to art societies and groups. Wendy loves to inspire others to paint in a free and relaxed style. 'It is amazing how eager students are to learn – art is a real life-saver and challenge and an artist is never bored!', she says.

Sources and inspiration

Wendy loves the countryside, farms and animals and brings these interests into her work. One of her favourite pursuits is to set off on her bicycle with her husband Paul or her grandchildren, who are all painters, and enjoy the outdoor life, taking their sketching and painting materials with them.

Combining her love of nature and the teaching skills required for different media, Wendy has made four art videos, written eleven books and writes regularly for art magazines, including *Leisure Painter*.

To capture all the inspiration and reference she needs for her classes, paintings and books her subject matter ranges from small intimate garden corners and intriguing farmyard doorways to the sweeping landscapes of Tuscany, from the lively reflections found in the canals of Venice to gentle harbour studies in Bosham, Sussex. Everything and everywhere inspires

Wendy. Her courses cover techniques, including basic drawing, wet-into-wet and mixed media, as well as specific subjects such as farmyard and harbour and seascapes, and she instils her enthusiasm and love of art to all who are taught by her.

Wendy exhibits in joint and single shows in galleries in London, Surrey, Hampshire and Cornwall.

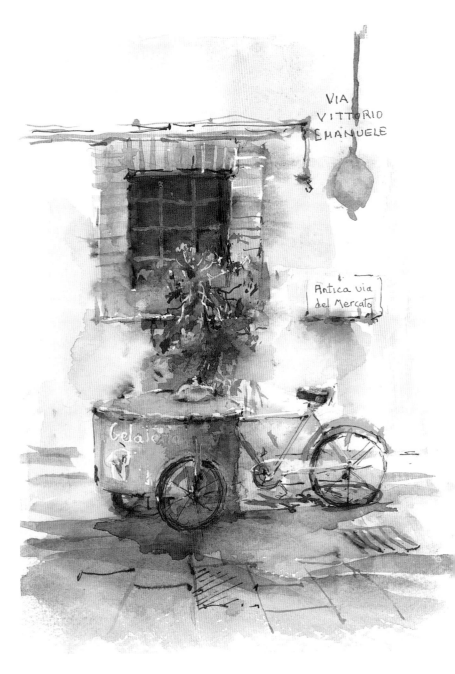

▲ Ice Cream Bicycle
25 x 20 cm (10 x 8 in)
This was a quick painting in sepia inks and watercolours for my students on an art holiday near Siena. It had to be fast as the bicycle was about to be ridden away!

Introduction

Pen and wash merges two different approaches to art. It combines the discipline given by fine, crisp and sharp pen lines and a complex tracery of ink marks with the looser, softer application of ink or watercolour washes, producing many diverse and exciting results.

Working with pen and wash appears relatively easy when crafted by an experienced artist, but to develop both artistic methods so that they balance and harmonize in one picture requires some patient study. The approach can be uniquely interpreted with each picture as pen and wash can be executed on a large and bold scale or in delicate miniature, as a spontaneous doodle or a time-consuming detailed study or exhibition piece.

Whatever your levels of competence of drawing and painting, I hope to encourage you to explore many aspects of using pen and wash and help you to discover your own style. Just as handwriting is individual to each person, so a pen and wash style lurks inside ready to blossom and to be recognized as particular to you. Naturally, as with all aspects of painting, there are basic techniques to be learnt and many disciplines to be acquired and mastered before you can develop your style fully. But you are already reading this, so you have taken the first step!

Versatility

Pen and wash offers a versatile medium that can be adapted to any style, but learning to

▼ Clematis
18 x 27 cm (7 x 10½ in)
Here I used waterproof inks with a free application of watercolour. I loved the contrast of the vivid orange wall with the violet flowers.

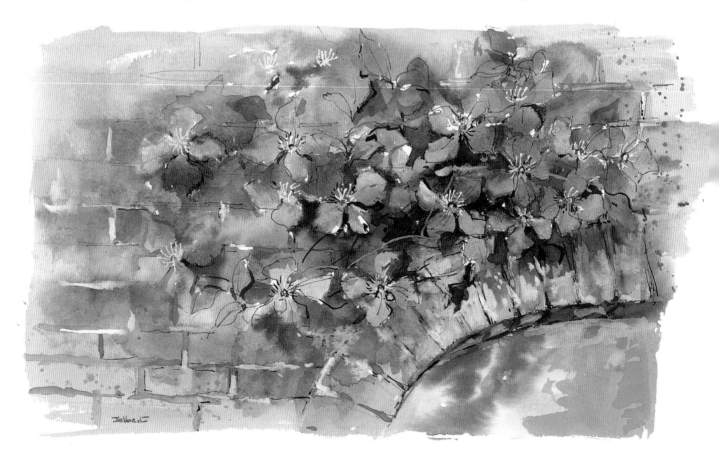

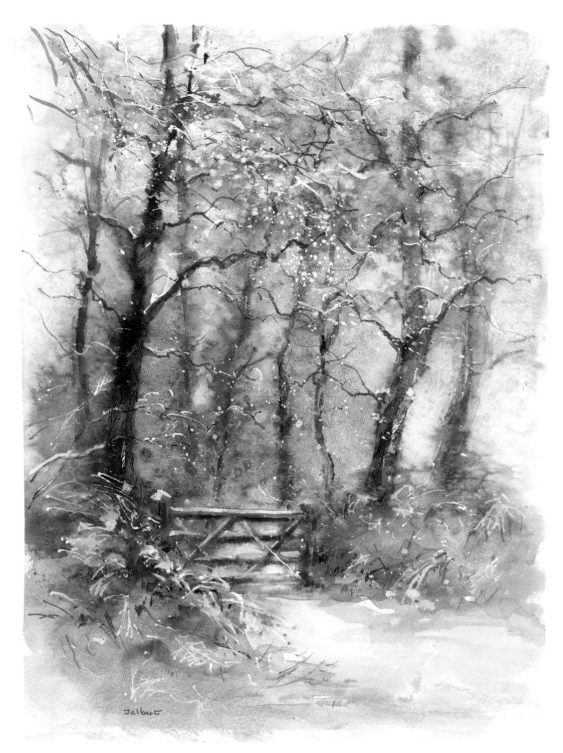

▶ Winter Wonderland
38 x 28 cm (15 x 11 in)
I used a sepia water-soluble pen, which diffuses with the watercolours. I used salt and masking fluid with the first wash, to give variety and interesting effects.

integrate the two into one can involve several stages. If you have had some experience with drawing and painting you have a good head start, but using pen and line along with wash as a medium requires specific techniques. First you must get to grips with your materials, then learn to control the differences between washes and

drawing, and how to combine and enhance them as required.

It is the great diversity of effect that intrigues when using pen and wash. The combinations are endless since each artist interprets a subject in a different way. This book suggests the potential of several methods to help you experiment with

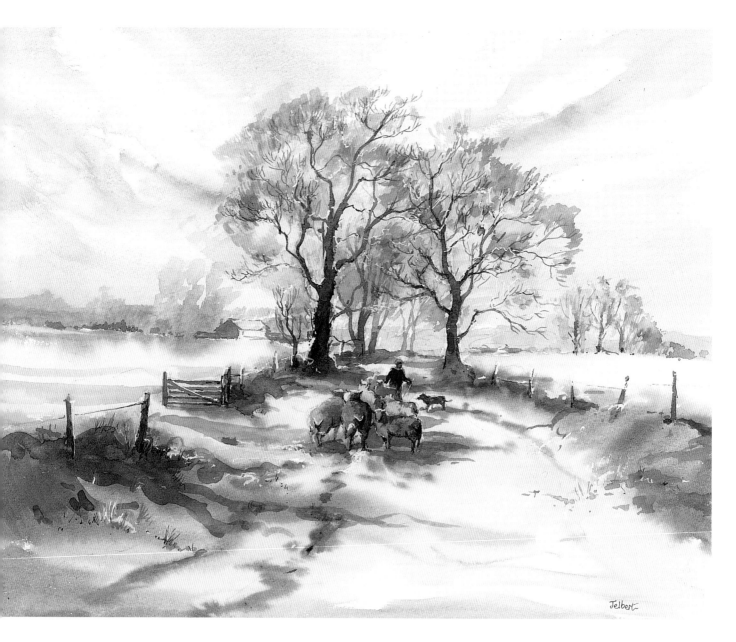

alternatives, such as using water-soluble sepia ink into watercolour to create the softness needed for distant trees or a black brush pen used in bold outline for the dramatic and spontaneous movements of people in motion.

Learning from others

There is an advantage in studying other artists' work in pen and wash that will inspire you to experiment and to persevere. You will find it helpful to copy works you admire to discover why they are successful, or even how a single line is translated in capturing a chosen effect. Many illustrators use pen and wash and their work is enjoyable and individual. There is always something new you can learn by just looking hard at the way they have applied colour to their characterful ink drawings. All this will enrich your understanding of this complex medium.

The basics

The book covers a range of subject matter, including figures, boats, buildings, trees, flowers and gardens, so there should be something of interest for everyone. Various

▲ **The Shepherd**
29 x 38 cm (11½ x 15 in)
The use of a warm watery Yellow Ochre wash in the foreground contrasting with Coeruleum in the background gives a convincing sense of distance. The effect is compounded by the tones and receding sizes of the trees.

ways of approaching different subjects are suggested, with easy exercises that you can try for yourself to practise techniques and processes such as textural markings, mixing greens, laying washes and planning compositions. Step-by-step demonstrations take you through complete projects using different types of inks and washes.

Pen and wash is one of the most economical of media. All you need to start is paper and a pen and ink, gradually progressing to more elaborate materials later. The pen and wash 'journey' is well worth taking as there is always something new to learn and an adventure to experience at every stroke!

▶ **Chickens**
39 x 28 cm (14½ x 11 in)
The delicious effects of coloured inks used in painterly manner, with the addition of bold and spontaneous drawing lines, captures this fleeting moment.

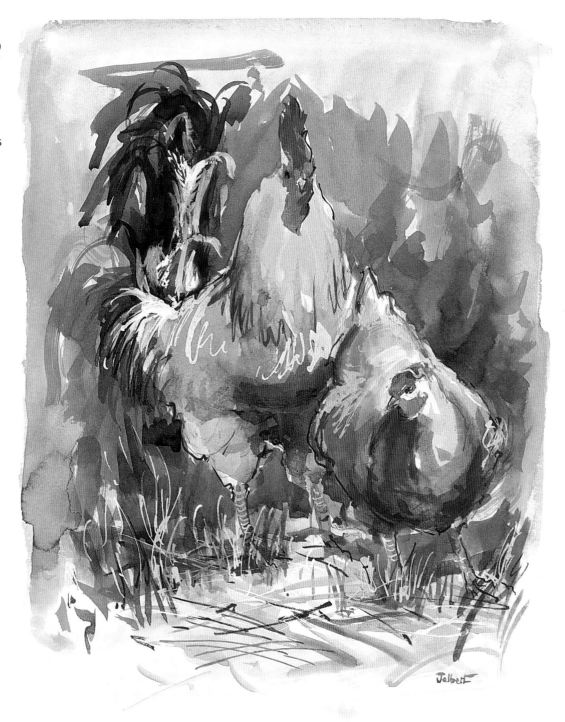

Materials and Equipment

Pen and wash involves using both drawing and painting materials. 'Pen' work can be executed with a wide range of water-soluble and non-water-soluble pens, felt-tips and brush pens, and the 'wash' materials include inks and watercolours. Although there is quite a variety of equipment to choose from it need only be simple. It is easy to waste precious pennies on unsuitable items, so it is best to build up and increase your pen and wash kit as your skills develop. Artists' materials exhibitions provide a good showcase for the latest equipment and these are well worth a visit as you can try out everything on display.

Inks

Coloured inks are produced in bottles in many assorted shapes and sizes and by many manufacturers. They can be blended and lightened by adding water and are available in an exciting range of colours and compositions including acrylic inks, calligraphy inks and pearlescent varieties. Some specialized makes such as the Rowney Kandahar drawing inks are brilliant and transparent though not guaranteed permanent, while others such as the

FW Liquid Acrylic artists' inks are extremely lightfast, waterproof and available in a wide range of both strong opaque and transparent colours. A recommended palette of acrylic inks includes Flame Red, Process Yellow, Yellow Ochre, Rowney Blue, Olive Green, Purple Lake, Antelope Brown, Sepia and Indian Black. Further colours can be added gradually as you become more familiar with using your inks.

▼ An array of coloured inks in assorted sizes and by various manufacturers. They include calligraphy, pearlescent, acrylic and drawing inks.

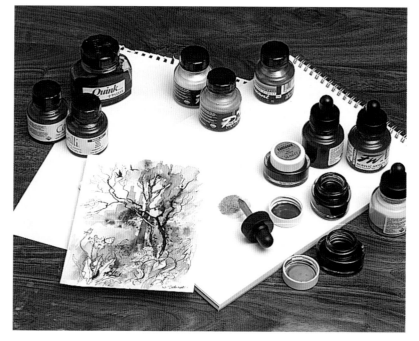

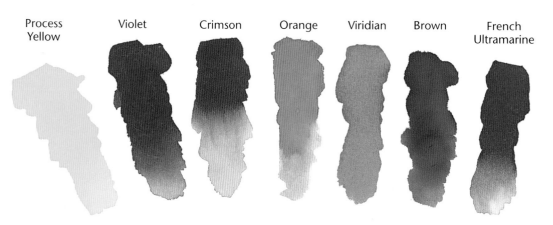

Process Yellow | Violet | Crimson | Orange | Viridian | Brown | French Ultramarine

◄ I like to have a selection of different makes of acrylic inks. This gives me the widest range and choice of colour in my palette.

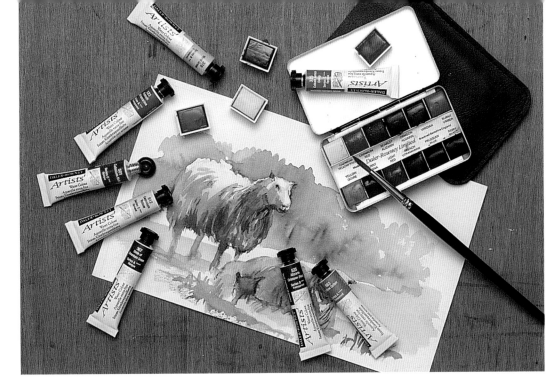

► Even after years of painting I find I still get excited by a selection of paints, whether they are in pans, sets or tubes. I use a delightful tiny paintbox especially for my location work.

Watercolour paints

I advise you to buy a miniature pocket-size box of artists' quality watercolour paints, ideal for painting out of doors as it is lightweight and takes up little room. There are several available to choose from, and I use the Daler-Rowney 90 x 63 mm (3½ x 2½ in) size. I also recommend a good-quality watercolour box of at least ten or twelve colours either in pans or tubes. Sometimes I use pans, but for larger washes I prefer to use tubes, especially when working in the studio.

The twelve colours that form the basis of my palette are Cadmium Yellow, Burnt Sienna, Yellow Ochre, Coeruleum, Cobalt Blue, French Ultramarine, Olive Green, Permanent Mauve, Alizarin Crimson, Raw Umber, Warm Sepia and Cadmium Red. I also add Vivid Green and Cadmium Orange to my palette.

It is advisable to experiment and learn how to mix your paints for a wide range of colours. Once you are familiar with these, you can add additional colours.

Students' quality paints are cheaper and more opaque than artists' quality, but the latter are recommended for permanence and translucency. Many artists have a cross section of both types for variety.

When replacing a colour always mention the manufacturer's name as colours vary considerably from one make to another. With any new colour I always test out how light I can make the tones by diluting, then experiment how dark the colour will go by using it almost neat. It is essential that you become familiar with the tonal range of each colour you have.

▼ This is a useful basic watercolour palette.

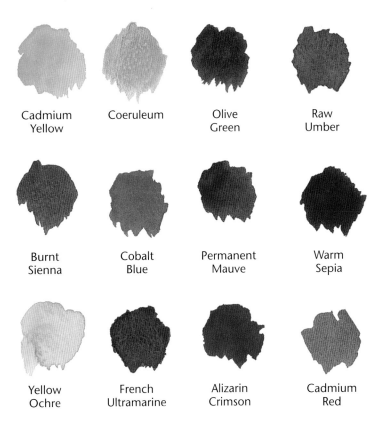

Cadmium Yellow	Coeruleum	Olive Green	Raw Umber
Burnt Sienna	Cobalt Blue	Permanent Mauve	Warm Sepia
Yellow Ochre	French Ultramarine	Alizarin Crimson	Cadmium Red

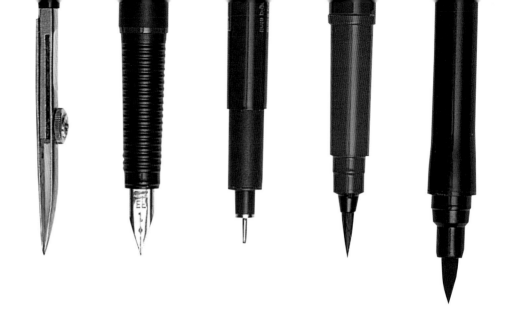

► A huge variety of pens is available nowadays. My favourites include a ruling/drawing pen, fountain pen, steel-nibbed pen, brush pen and felt-tip pen. These are the pens I use regularly to capture the wide range of markings and tonal effects that I need.

Pens

Pens are versatile, portable and economical art tools. There are so many makes, shapes and sizes that you may find it extremely confusing to choose which ones are right for you when you start pen and wash. They are either water-soluble or non-waterproof and can be bought as felt-tipped, dip, steel-nibbed, cartridge or brush pens. You may need a selection of each to enable you to achieve the range of marks needed for your exciting projects ahead! I advise you to have both sepia and black basic ink pens as this gives you options when you need them. The sepia pen can be useful for generally tying a composition together, while the black one is used for more obvious features.

Brushes

Again, there is an amazing choice of brushes to choose from, but buy the best you can afford. The man-made imitations are excellent nowadays. Rowney's Dalon is an economical and popular make and I have several of them that I constantly use. I also use a number of soft-hair brushes made from ox-sable or squirrel mixtures.

The sizes I prefer are flat and round-headed size 10, a round-headed size 5, and a rigger size 1. Using too small a brush will make you fussy and fiddly in your work, while a choice of too many brushes can be confusing. Find out how many marks you can make with each brush by dragging, dotting, turning, swishing and experimenting with large and small strokes. Sometimes you need use only one brush for nearly every mark, especially if it has a good point and holds water well. I find my oxhair filbert size 10 brush is ideal for travelling and for some of my studio work.

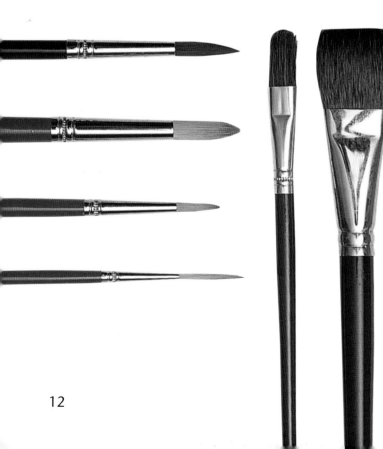

◄ The choice of brush size, shape and type of bristles remains open ended. I use different brushes ranging from flats and filberts to round-headed brushes.

Paper and sketchbooks

The rule of thumb is to use a thin paper for sketching. Either a cartridge paper or 190 gsm (90 lb) watercolour paper is suitable for small studies with washes.

Heavyweight cartridge is ideal both for washes and for drawing. This type of paper can be bought in pads or spiral-bound book form. Each paper has a specified weight and surface, the latter categorized as smooth (hot-pressed), Not (not hot-pressed) and rough. With experience and personal preference you will decide which you need. My favourite watercolour papers are Langton and Saunders Waterford blocks and pads. I use a 300 gsm (140 lb), Not surface for a full painting with washes. A smooth surface is best for delicate work.

Coloured papers are excellent and adventurous for some pen work and watercolours.

Sketchbooks are essential for outdoor studies. I prefer a hardback sketchbook of cartridge or 190 gsm (90 lb) watercolour paper about 25 x 20 cm (10 x 8 in). There are many sizes on the market and they vary from portrait to landscape format. You can also buy one that has a variety of different papers that range from 190 gsm (90 lb) to 300 gsm (140 lb) with watercolour paper and cartridge surfaces all in the one book.

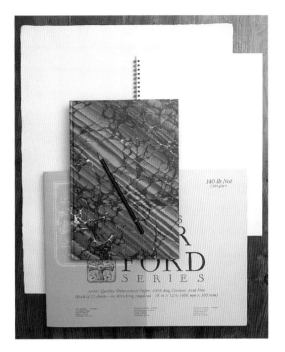

◄ Watercolour and sketching papers are available in book, pad or sheet form. I especially like these colourful hardback sketchbooks – they are great for keeping a permanent record of artistic memories!

Other items

You will need pencils for drawing, kitchen roll, a water container, a drawing board and a palette to mix your colours on. Plastic palettes are light and portable and have compartments suitable for both washes and squeezed paint. I use masking tape to secure my paper while working. A seat-rucksack holds all my simple outdoor items.

Use a soft eraser for correcting mistakes and as a tool for smudging, lifting out or highlighting. Masking fluid is also essential.

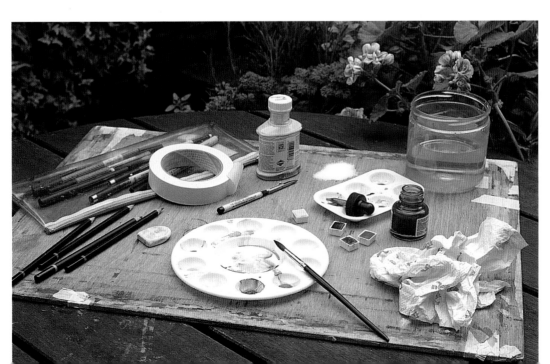

◄ Here is some of the extra equipment needed besides the basic materials, including pencils, eraser, palettes, kitchen roll, masking fluid and a large drawing board. Even though my painting equipment may seem chaotic to the onlooker, I try to be organized and to have everything I need readily to hand.

Basic Techniques

The attractive individuality of pen and wash depends on the mastery of balancing and creating effects with inks and washes. It relies entirely on the application of pen work and inks in crucial stages. You have several choices – either placing your pen work initially and then adding colour; or applying colour first and then pen work; or adding ink and colour stage by stage.

The results will depend, too, on the kind of ink you choose, and what subject you have chosen. A softer diffused effect such as a distant building or an 'out-of-focus' tree will need a non-waterproof ink, so that it runs and oozes into the colour, whereas a bolder and stronger image, such as a finely detailed façade or garden feature, may need a waterproof pen. The application of pen work must not be too fussy or intricate if colour is to be added, but should provide spaces for the colour to nestle and balance the ink drawing. Excessive ink drawing does not compensate or save a coloured picture,

but rather the opposite. Too much pen work emphasizes the bad points of a composition and the picture can die screaming and kicking in a tangle of ink work!

Getting started with inks

How do you know 'what and when' to use your assortment of inks? My advice is to leave out about one third of all detail so that you do not take on too much.

If a loose effect is needed, a 'flowy' quality will have to be apparent in your application of inks and washes. Use a water-soluble ink and wet the paper before you start to apply it.

If a more detailed approach is needed, use a waterproof pen with a finer nib – say, 0.1 or 0.2 – still keeping in mind not to overdo the background and outline everything in sight. Also remember that the more pen work the simpler the colours needed, or a complicated muddle will result.

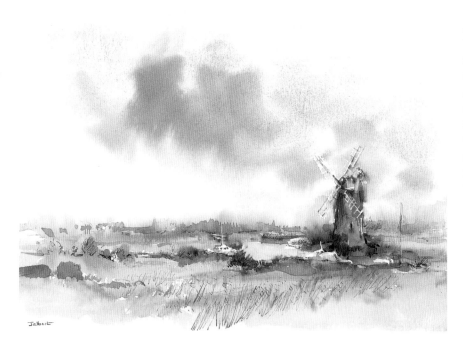

◀ Norfolk Windmill
20 x 28 cm (8 x 11 in)
This was painted in situ in watercolours and detailed in using a sepia steel-nibbed pen and water-soluble ink around the water area, which I then rewashed so that it would gently run and soften into the landscape.

▲ Dip the ruling/drawing pen into the ink, then quickly clean the sides so that it will not blob. Hold the pen at an angle of 45 degrees. The wheel on the nib's edge governs the thickness of the line.

▲ Applying ink with a brush produces expressive varying lines depending on the size and shape of brush used. I use a round-headed oxhair brush size 6 for most of my ink brush work.

▲ Many bottles of coloured inks have a dropper, which is ideal for applying line or blobs of colour. A dropper is especially useful for 'wet-into-wet' work, when the colour merges and blends.

Ways of applying ink

Becoming familiar with your materials and knowing how they work builds confidence. You can apply coloured inks by pen, brush or dropper. Practise making a range of marks using different means of application.

Adding colour

How do you add colours? The secret is keeping the washes of either inks or watercolours clean, simple and clear. A flow of colours connects areas to one another, adds depth, and creates a cohesive feel to a picture. To obtain a soft pastel shade, add plenty of water to dilute it. A deeper hue needs much pigment and less water. Colour runs beautifully on a wetted area, while hard edges are created on dry paper, and both effects have their place in pen and wash.

The right approach

Using these varying combinations of ink and colour may seem quite confusing and complicated when you are a beginner. Try setting yourself a simple still life so that you can concentrate on the techniques rather than the subject matter. Just experiment and enjoy the 'mix and match' of colour with inks.

a
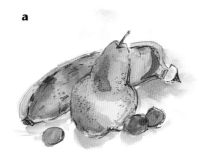

a Waterproof sepia pen work overlaid with watercolours.
b Non-waterproof sepia pen work overlaid with watercolours.
c Integrating line with creating tone using black waterproof ink.
d Using watercolour washes with pen work overlaid.
e Using coloured inks with pen and washes.

b
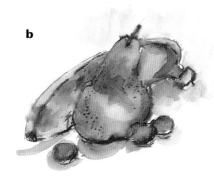

c
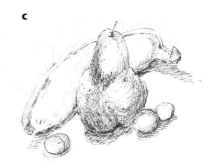

d
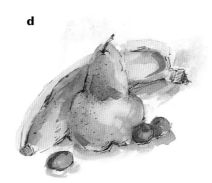

e
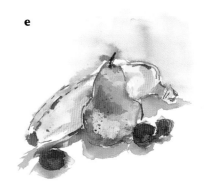

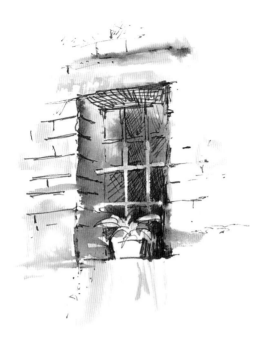

▲ Using waterproof ink and crosshatching pen work to achieve tone and structure.

▲ Using water-soluble ink with masking fluid.

▲ Combining both methods, adding texture and washes.

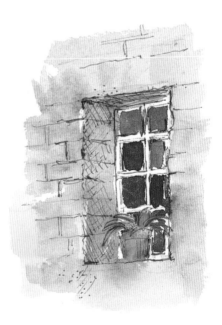

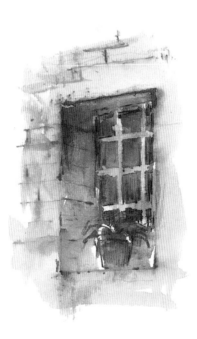

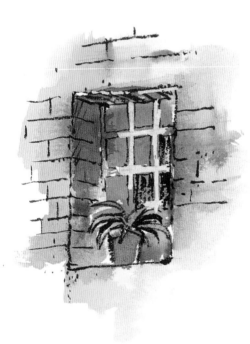

▲ Using watercolours over a waterproof pen drawing.

▲ Using sepia water-soluble inks with masking fluid and watercolours.

▲ Using a bold brush pen under colour ink washes.

Practice subjects

Choosing a subject that will adapt to all these methods of application would be another useful exercise for you to try out for yourself (see opposite page). A picture has to look natural and seem to flow with the media, not fight against it. At first keep it simple, using waterproof ink for details and light lines on subjects such as buildings and boats, and non-waterproof ink for softness and distance. Try a subject in both kinds of ink, with colour added first, then added later. The more practice you do, the better you will become. If you cannot decide which methods to use, try out several ways to find which you prefer. Experimentation will make you discover your own methods, and eventually your own style. You may find, even though you have predetermined how to proceed, that the subject dictates a different procedure. At other times your emotional response or desire for a change will determine another range of methods.

The use of masking fluid

I have mentioned using masking fluid. This comes in bottles and is usually a yellowish colour. It should be the consistency of milk and should be applied as a runny liquid. Many makes are far too thick and even clear coloured, so you are unable to see where you have applied it. First pour a little away – approximately ten per cent – if it looks too much like 'cream', and fill up the jar with water. Colour it with a little watercolour, so it is easy to see where you have applied it.

When you have details such as grasses, masking fluid can be drawn with a ruling/drawing pen onto the paper, then allowed to dry thoroughly. Paint as normal again and let it dry, then rub off the masking fluid with your fingers. This reveals white 'ghost' markings, and these can be repainted to blend into the picture with a soft colour. This is quite an important technique to use with colour washes.

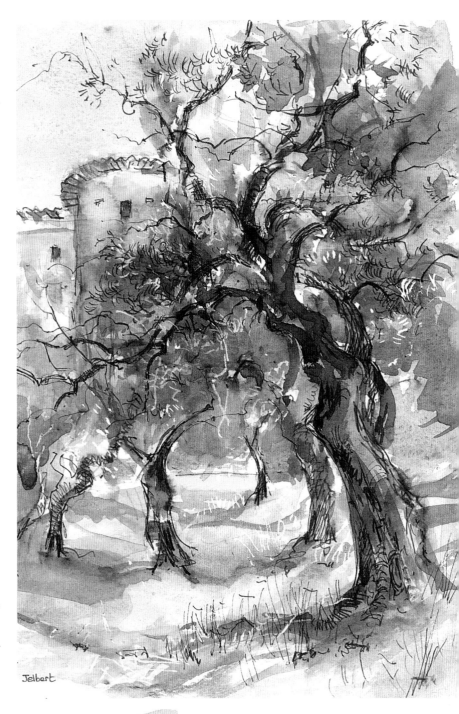

Jelbert

Make sure masking fluid does not leak or drop on to clothing or brushes. If it does, wash it off immediately before it dries.

▲ Olive Trees in Tuscany
28 x 20 cm (11 x 8 in)
Several techniques are used here – drawing in waterproof and non-waterproof inks, masking fluid used for highlighting, and added watercolours.

17

Understanding Tone

When you draw or paint from observation you are attempting to portray the reality of what you see to the best of your ability using the techniques you have available. To do this successfully you need to understand first how to capture the correct sense of depth, solidity and distance, or in other words how to describe the tones effectively. Tone describes the degree of lightness or darkness of a colour. There is no magic formula or wand to wave that will save an unsatisfactory picture if this understanding of tones is lacking.

In pen and wash some dedicated study is required to recognize and place tones correctly since the two media are used differently. The aims of composing light, shade, depth and drama are similar, but the tight tracery of pen work made with only a pen's surface nib differs considerably from the flowing ink and water washes applied with the aid of a brush and water. It is possible to achieve a great variety of tones using a pen, as well as great contrast of light and shade.

Creating tone with pen

The simplest form of applying tone using your pen, whatever colour or type, is by building up a network of crosshatching. Start with downward movements and then hatch horizontally and diagonally using more marks closer together. Apply more pressure to give emphasis to the deepest darks, and lessen the pen strokes to allow more paper to show through for lighter tones. The palest tone is captured by making just a few soft random marks, leaving most of the paper untouched. Recognizing how these areas of tone work with each other will help you create a successful picture.

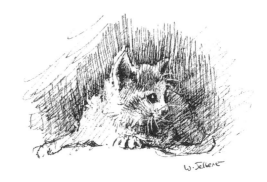

◄ Create tones by crosshatching the pen marks in different directions.

◄ **The Kitten**
5 x 9 cm (2 x 3½ in)
Squiggles or broken lines used at different angles and massed in specific areas can create depth and structure effectively.

Accent and balance

There needs to be an accent of contrast in a good composition. This is an area that contains both dark and light, giving tonal contrast and dramatic content and is where the strength of the picture lies. The balance of counterchange between the darks and lights has to be carefully worked out as this governs which areas recede and which become dominant and highlighted.

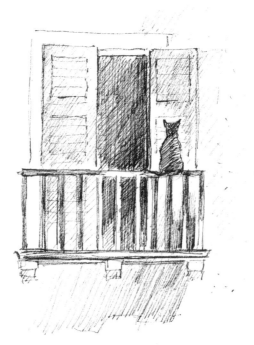

◄ **The Balcony with Cat**
14 x 10 cm (5½ x 4 in)
The dark cat shape and two thirds of the balcony contrasts with the light shutters behind, while the dark interior highlights the light one third of the balcony. The whole drawing is worked out, as well as each area separately, so that it is tonally balanced.

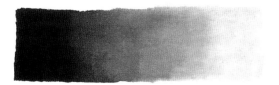

▲ Graded wash
Start by applying an almost neat wash using a large brush. Working fast, add more water to each layer of wash so that it is progressively more pale and watery than the previous one.

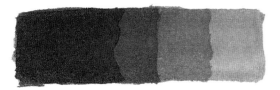

▲ Overlaid wash
Apply a wash all over an area and leave to dry thoroughly. Then, using the same wash, overlay part of the original. Repeat this process several times.

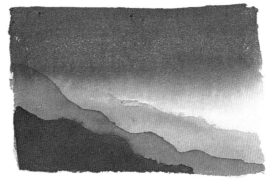

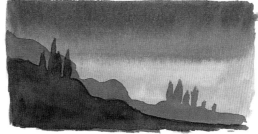

◄ A varied assortment of washes is used in these two blue and black thumbnail studies of landscapes to give the impression of dramatic distances. Breathtaking results can be achieved by using a variety of silhouetted shapes, each overlapping one another and perhaps portraying hilltops, buildings or trees. Notice how much richer and darker the tones become with each application of wash. Experiment to discover the darkest to palest potential.

Creating tone with wash

You can create a range of tones using a wash either with your inks or watercolours. Grade your neat colours by gradually lightening them with added water and apply the wash with a brush.

Washes can be used in a variety of ways depending on your subject matter and the effect you wish to create. You can gently grade a wash from dark to light in one stage or by overlaying the same wash in different stages and letting each stage dry thoroughly. The underlying wash is considerably intensified with each subsequent application.

Combine these two methods by placing blobs of tonal washes together, say for a moody sky or rough sea, applying another wash over the area as a glazing when dry.

Combining pen and wash

Using your pen and wash in a diverse combination of both massed pen drawings and tonal washes can be a challenge. Neither technique must overshadow the other, but both should work harmoniously together.

Areas of darker washes can easily be worked into with an assortment of varied pen marks. Equally, you can overwash pen work with a tonal wash to soften an area or to create diffused effects. Simply experiment tonally with pen and wash in a way that interests and excites you.

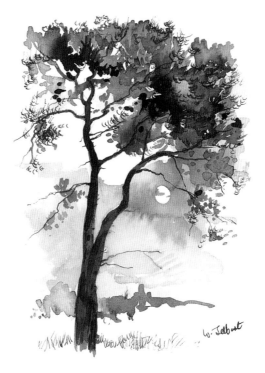

◄ **Tree in Moonlight**
18 x 13 cm (7 x 5 in)
The tonal washes and massed pen work were intertwined in this study. I applied washes for the sky, the foliage and background. Massed pen work was added to the darker foliage wash, thus giving it more detail and interest. I left the white paper for the sky behind the main foliage area and the moon shape.

Using Colour

Another way of building up areas of interest and tone in a pen and wash drawing is to combine the line element with washes of diluted watercolours or inks. This allows you more freedom, producing individual rapid and expressive ink drawings. Vary the style, colour and inks to suit your chosen subjects.

The basics of colour use

Colour adds mood, excitement and vibrancy. The primary colours of yellow, blue and red cannot be mixed from any other colours. By adding two of these colours together, however, you can make secondary colours. Thus, mixing yellow and blue gives green, yellow and red make orange, and blue and red produce violet. Tertiary or intermediate colours such as blue-violet or yellow-green are formed by mixing a secondary with a primary colour.

The third primary colour that is not used in any secondary pairing is said to be complementary to the colour produced by mixing the other two primaries. So, orange complements blue, red complements green and violet complements yellow.

The complementary colours are extremely important as they enliven or contrast with one another. Placing them side by side makes the colours 'sing', as in a red poppy field with lush green foliage. Adding a little of the complementary colour will subdue or neutralize a colour, essential for a more grey or toned-down area.

Try and limit yourself with a few colours in your watercolours and inks. The palette I have advised on page 11 should enable you to mix a good range of intermediate colours.

▶ Apples
28 x 30 cm (11 x 12 in)
I used FW artists' acrylic inks for this vibrant study of apples and other fruits. First I made a rapid drawing in Emerald Green over the background using an ink dropper, then added a combination of Cool Grey, Process Yellow, Rowney Blue, Scarlet and Process Magenta for the fruit, using broad strokes with a size 12 flat-headed brush.

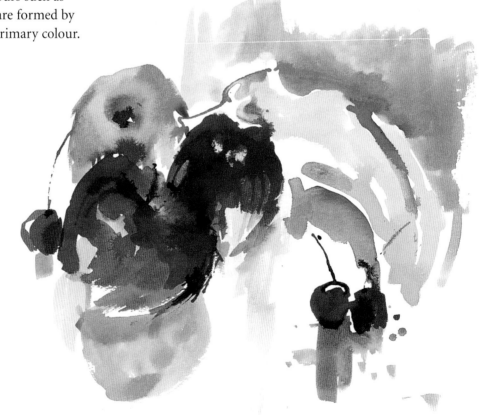

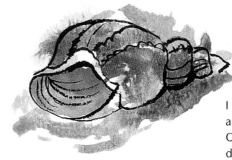

A bold outline drawing in waterproof black ink using a brush pen or ink with a bamboo pen.

I wetted the surface and used Violet, Orange and Scarlet drawing inks, letting the colours bleed.

I drew gentle guidelines and painted in with soft watercolours.

Using a fine (0.1) steel-nibbed sepia waterproof pen I pin-pointed the structural lines and patterns of the shell.

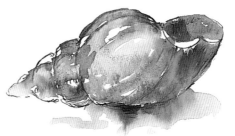

I sketched in the shell shape using water-soluble sepia ink.

The penwork diffused as I painted watercolour on top.

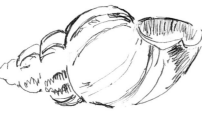

I used a fine disposable pen with blue water-soluble ink on top of gentle guidelines.

Watercolours were added, letting the image bleed into the original drawing.

When adding colour to any subject take care that you do not make it all look too complicated, such as using too much textured drawing with too many assorted colours. Try to keep a fine balance between the pen drawing and the coloured wash. Experimenting with one subject will help you choose appropriate combinations of line and washes. Try several different subjects and explore the effects more fully.

21

Colour overlaid on ink

Choosing only one subject can simplify a practice project. Not having to continually draw a separate subject at each attempt will allow you to concentrate only on developing your ink drawing techniques. Drawing skills, like writing, can be acquired, so do not feel despondent if you are not as successful at first as you wish. Motivation is just as important in mastering a set of techniques!

Start by drawing your chosen subject in a number of different inks – I decided to use carrots and their foliage. By adding orange and green watercolours on top when the ink has dried, you will soon discover how the media work together and the different effects they create.

▶ This exercise embraces a wide range of related, but different, attempts at developing pen drawing in a variety of inks with added colour.

a A heavy, bold waterproof ink using a nib or bamboo pen.
b A brown felt-tipped waterproof pen.
c A black non-waterproof ink. The drawing becomes predominantly blackened with the watercolours added.
d A black non-waterproof felt-tip. Again the colour runs, but not so violently.
e A steel-nibbed (0.1) pen. Open 'woven', delicate lines offer a more sensitive approach.
f As **e** but with a non-waterproof ink.
g A steel-nibbed sepia waterproof (0.1) pen that shows more of the watercolour.

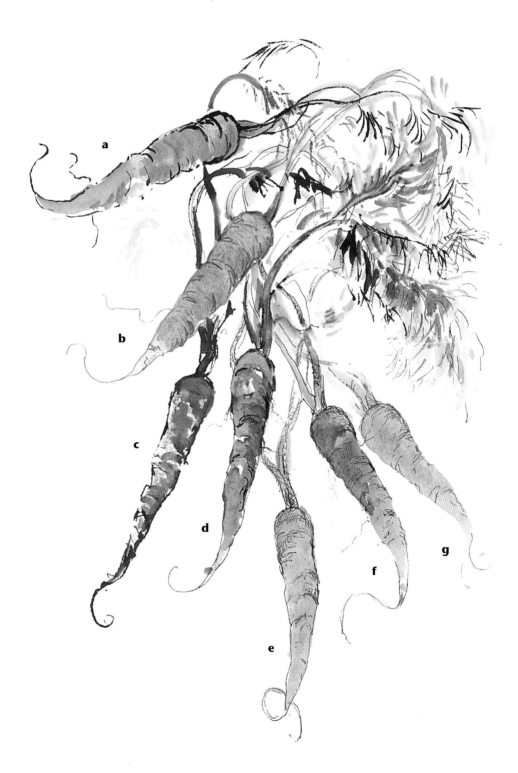

Ink overlaid on colour

I chose autumn leaves for this exercise. They make a delightful and ready subject for painting and drawing in pens and coloured inks. The transparency of this medium plus its brilliance makes it equally ideal for fine as well as loose work. Drawing inks can be intermixed, they flow easily and can be overlaid in glazes. I used the Rowney Kandahar range in Yellow, Orange, Crimson, Sepia and Viridian. The colours are so overpowering that you will notice how bright they are before discovering how the ink drawing techniques were done!

You can draw into the colours using a traditional pen or a ruling/drawing pen with brown or black inks. I sometimes spatter colour into the leaf shape while wet to achieve a natural weathered look. Use brightly coloured inks to draw over the initial subject and compound the effect.

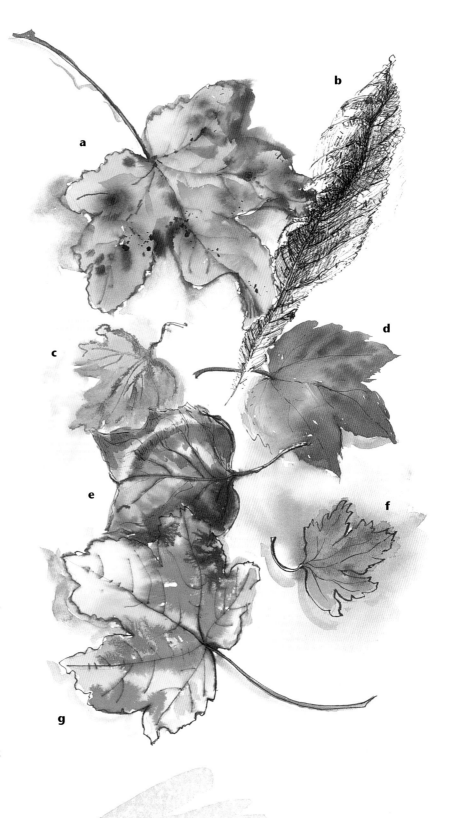

▶ For this exercise spread out each selected leaf and experiment using combinations of inks into colours. Instead of leaves you could also try drawing sweets and flower petals.

a After a non-waterproof outline in sepia, I washed over ink glazes of yellow, brown and green.
b This was a monochrome, using only black ink markings.

c On a wetted yellow ink surface, I drew in with a ruling/drawing pen using a red ink.
d Crimson and yellow blended over a waterproof dried ink drawing.
e A sepia ink wash over a sepia ink drawing.
f A bold black drawing on top of a dried wet-into-wet ink wash.
g A black non-waterproof ink drawing with wet-into-wet ink washes.

When working with pots of ink place them in a saucer on top of a napkin – this will prevent accidents!

Capturing Light

Light has many different qualities. It is the light falling on a subject that tells us whether something is flat or round. The way in which it illuminates the subject depends on its strength, hence the difference between soft moonlight, mistiness or bright sun, and its coldness or brilliance can be used in art to portray emotions such as happiness, calm or sadness. The type of lighting is also vital in setting a scene, whether natural, as daylight or candlelight, or artificial, as electric or neon light.

Of course, too, the source or direction of light casts shadows and highlights the subject. A good way of understanding the importance of this is to practise with an arrangement of contrasting shapes such as mugs, bottles and boxes. Shine an electric portable light at different angles and notice how successful certain shadow shapes can look or how they can detract from your overall composition.

Preserving the light

The effectiveness of light in your drawing and painting will depend on how you protect the white and light areas with the techniques you have at hand. Preserving the white paper is essential in translating the 'glow' of light.

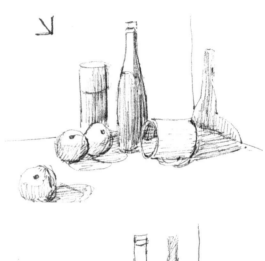

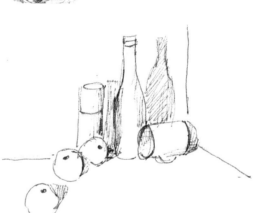

◄ A pair of still-life studies with light sources from different angles, creating unlit surfaces and distinctive shadows that connect the objects. Assorted light sources give ranges of effects, from dramatic shapes to gentle outlines. It helps if you can denote the direction of the light with an arrow, especially when sketching outdoors.

► **Snowfall**
14 x 17 cm (4 x 6½ in)
I used a very limited palette of Warm Sepia, Yellow Ochre and Coeruleum watercolours. I spattered the masking fluid on the right-hand corner of the picture and used a ruling/drawing pen to apply masking for the finer and lighter details. Tiny pen marks were added with sepia to tie together the final stage of the picture. Areas of the snow were simply left as white paper.

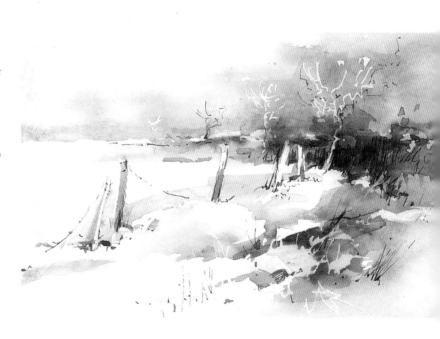

Masking fluid is one method you can use when working with watercolours or inks (see page 17). It is applied easily with a ruling/drawing pen that can be adapted readily to give a fine or heavier line by adjusting the small wheel between the metal nibs. You can also spatter the masking fluid by flicking it to give a more random effect.

Using contrast

Capturing the illusion of light also depends on how you contrast the areas of light with the darker ones. The darker the tone you place against part of the lighter area, the lighter it seems to become. A glow of light using a pale yellow wash can also be added first as an underpainting, then the other stages added later, so that the glow remains underneath. An addition of white ink can recapture a light area, such as a highlight on a bottle, or seagulls in the sky. In the illustration of a duck shown here I have included several of these methods of using light to enhance the subject.

Lighter areas that are more delicate and complex, such as in net curtains, lace, waves and cobwebs, can be placed in with a pen or brush using white ink or masking fluid. These areas can also be softened with a Yellow Ochre wash afterwards for a warm effect or 'bleed'. Use a light blue for a shaded, cooler look. The darker colours, too, can have a little Ochre added to the wet stage to add a 'glow' to the darker shadows.

▼ Spider's Web
20 x 15 cm (8 x 6 in)
When placing a complex design in masking fluid remember to paint in a darker distance so that your hard work is not wasted – it has to show up! Here I graded the background colour for dramatic and subtle effects. Added details can be drawn in with white ink if required.

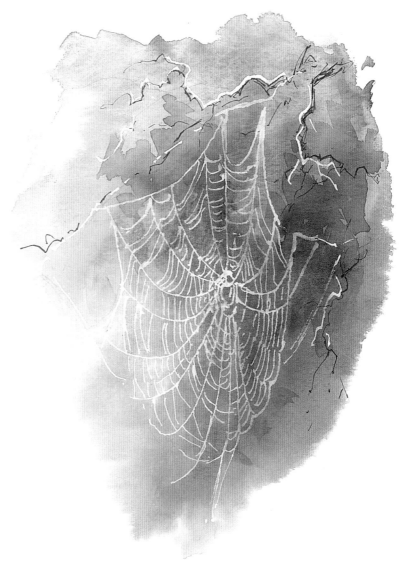

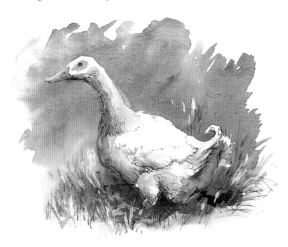

◄ Duck
14 x 17 cm (5½ x 6½ in)
I underpainted a pale Yellow Ochre wash on the neck, lower part of the body and grass beneath the duck to give the glow of light. A little white ink on the tail feathers and around the eye area enhances the light contrasts against the darker background.

Creating Texture

Creating a successful and 'effortless' picture that is full of character involves many important ingredients, of which one is especially vital – the use of 'visual shorthand'. This becomes a hybrid selection that each artist develops from his or her own set of markings. Each image distinguishes a particular textural surface such as wood, feathers or foliage and each artist discovers a way to describe this.

The beauty of pen and ink is probably most clearly expressed when its basic elements of line and space are used to best advantage. In many cases it is best to leave out finicky and superfluous details, and give only a brief suggestion. A complex treatment can destroy the impact of any picture, so concentrate on perfecting a more simple 'open', but accurate, drawing. The imagination is far more capable of visually filling in the remaining blank spaces and it is more satisfying for the observer to play a part in creating an image. This is an aspect of pen and wash work that comes with practice and experience.

Discovering your own artistic language

Creating a picture, whether from a photograph or from a landscape scene out of doors, involves selecting and simplifying everything that you see. At first sight you may feel you are faced with a confusing jungle of objects and textural surfaces, so it is helpful to break the 'chaos' down into

▶ I have extracted five different textural areas in this photograph of a small fishing boat. Each depicts an individual surface and character, and I used a black waterproof ink and a black steel-nibbed pen size 0.3 to draw them.

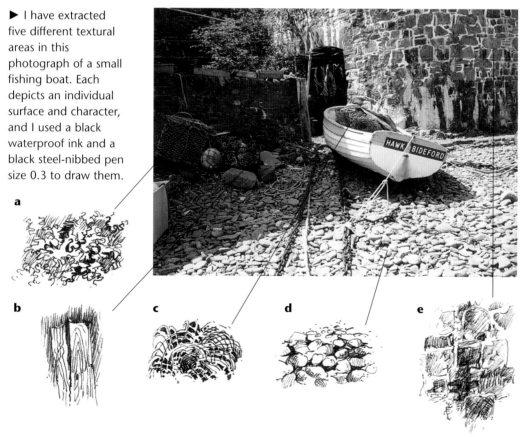

a

b

c

d

e

a Foliage
Describe this with a series of squiggles using an assortment of heavy and light lines between the shapes.
b Wooden post
Swirls of lines create the knots and ridges of the wood.
c Netting
Emphasize the criss-cross pattern and squares of the net as they mass together and overlap.
d Pebbles
Concentrate on the dark, subtle shading between the assorted curved stone shapes.
e Stonework
Vary the stone sizes and show a lighter mortar trail to connect the toned areas.

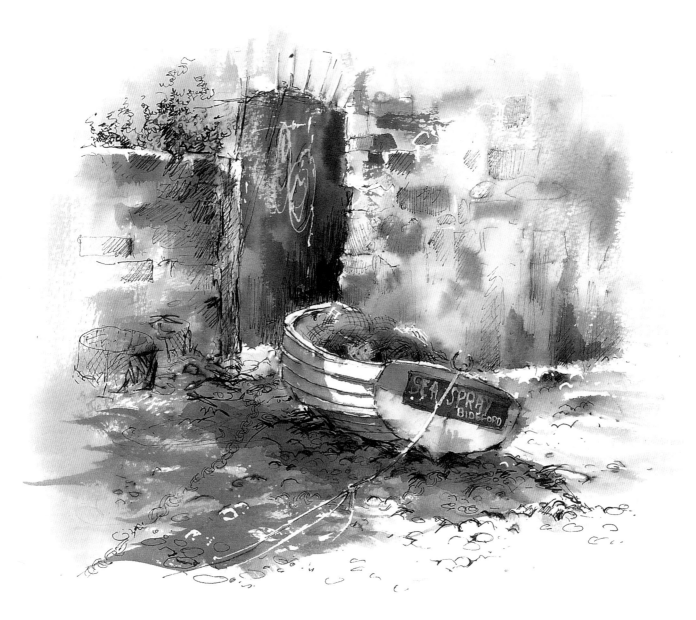

small areas. Try to capture the essence of the points you wish to include in your picture.

The best way to learn how to develop this visual language of selection is to look at as many artists' work as you can. Albrecht Durer (1471–1528) deserves special study for his book illustrations, woodcuts and observational graphic skills; John Ruskin (1819–1900) made exquisite drawings with fine detail and textural quality; and the energy and emotional turmoil of Vincent Van Gogh (1853–90) also flourished in his ink drawings. Experiment on your own, perhaps copying the effects and styles of well-known modern artists to learn how they achieve solutions to interpreting the subject matter before them.

Selection and simplification

Monochrome sketches in washes of ink and pen drawings are excellent devices to help in selecting final details for a finished picture. Simplifying textures and highlighting your darks and lights will all clarify the whole process of choice. Note these areas in this monochrome study of the boat shown in the coloured photograph on page 26.

You need not become a slave to all the details you see. Aim to master a few textural techniques well, rather than attempting to use all of them in one picture You could try out this exercise using another photograph of your choice with a challenging set of textures and see how you get on.

▲ **Fishing Boat**
25 x 33 cm (10 x 13 in)
A visual shorthand is exercised here with great restraint. I only accentuated small areas with details and faded them away. This left just one dominant section containing each varying set of marks, such as the netting in the boat, the pebbles beneath the hull, and the foliage over the wall.

Composition

The process of creating a composition can make or break a painting however beautifully it is painted. Whatever your source of inspiration, whether you are using a photograph, sketchbook or working outside, you need to answer a series of vital questions before you start. The time you invest in preliminary sketches and thoughts will be greatly rewarded.

Ask yourself some of the following questions. Where do you place your main features? What size should they be to create a well-balanced format? What shape should the picture be? What mood are you hoping to portray?

To help you make these decisions you could use a viewfinder in exactly the same way a photographer does. Hold it at arm's length, close one eye and look through the frame. By moving it about and perhaps altering the sizes you can decide upon the best composition within your frame.

The focal point

The focal point is the main focus of interest in the picture. It holds many important elements such as the lightest, darkest and the most detailed features. The focal point is also positioned in the most dominant position. Use a grid as shown here and place your focal point on one of the intersections.

Making compositional studies

Always try out several compositions. Make a quick spontaneous sketch of the scene – this can be quite inaccurate or out of proportion, but the idea is to capture the essence or spirit of your first reaction. You can then start developing your visual impressions into a planned composition.

▶ A viewfinder can be easily made from two pieces of 'L'-shaped card attached by two paperclips. The size can then be adjusted at will as required.

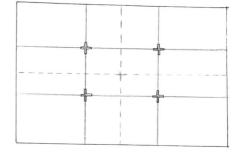

▶ This grid will help you in planning a composition. Divide your paper into three equal sections, then draw two equidistant lines horizontally and two vertically, forming four vital points of intersection or focus.

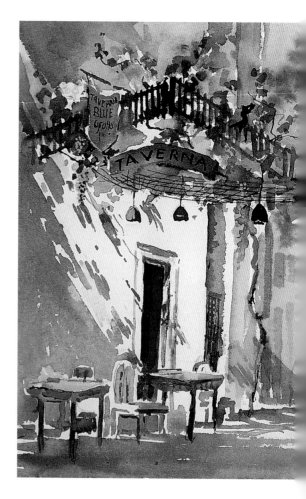

▶ **Blue Grotto Taverna, Paxos, Greece**
18 x 13 cm (7 x 5 in)
This is a sketch with added colour that I hope to use to produce a finished painting some day. It contains all the information I need to work more fully.

Developing your composition

Make a monochrome sketch to sort out the tonal values and place in the focal point. Another set of notes is useful to place in the details and colour – this can be done in words, colour marks or even as a small study in full colour. Back up your sketches with a photograph if possible.

The colour studies here show examples of some of the mistakes often made when planning a composition by not considering all the options. The right-hand picture of each pair offers an improved solution.

Avoid placing the main feature right in the centre. It will split the effect in two rather than creating a satisfying whole. Similarly, try to create variety with the elements that make up your picture and look carefully to check that you are not overlapping or placing features inappropriately. Use artistic licence to change their appearance or position.

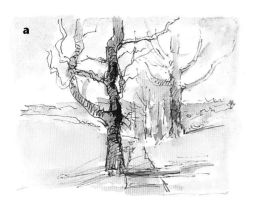
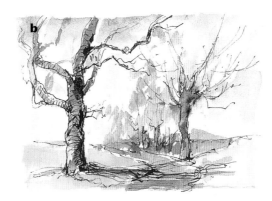

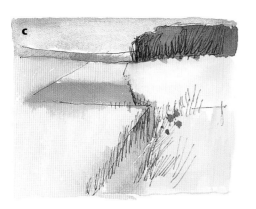
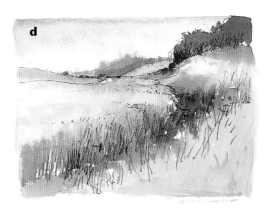

a Placing a main feature in the centre of the composition cuts the picture equally into two and looks unsatisfactory.
b Moving the tree to the left balances the format and opens the picture to the distant landscapes.
c The blocks of fields are too similar and the edge of the distant band of trees too central, dividing the skyline in half.
d Varying the fields, skyline and distant trees provides more interest and gives more scope towards the distance.
e Take care not to 'rest' distant objects on foreground features. Here the house is balanced on top of the posts!
f Move or change objects so they are not underneath or appear to support other features. Also soften them in tone to distance them.

Trees

Trees are the kingpins of many a landscape, countryside or garden picture. These beautiful and diverse visions of nature are the lifeblood of outdoor studies and so the artist needs to give proper care and attention in nurturing a better visual understanding of how to portray trees accurately.

Many painters find that trees present difficult subjects and remedying the problems takes time and effort. Many students seldom do much about learning how to do this and just hope that things will turn out as they wish as the painting proceeds – this, of course, never really happens and so something has to be done to improve the situation.

First, ask yourself two key questions. How many trees can you identify? Can you sketch a recognizable tree? Many a picture is spoilt by a stereotypical tree looking like a green whirlwind on a stick! Whether they are your 'demons' or 'darlings' to draw and paint there is no escaping from the fact that there is a challenge ahead for all of us.

Knowing your trees

I enjoy just looking at the trees in front of me for a few minutes before jotting down any information in my sketchbook. I roughly trace around the shape and forms

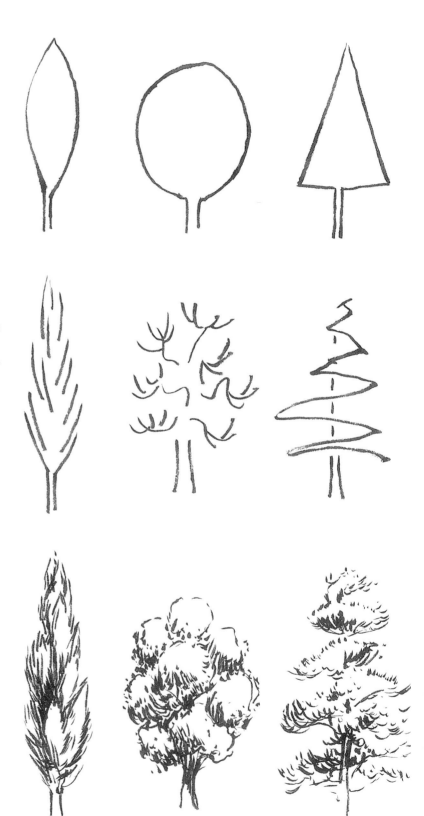

▶ When observing trees, there are roughly three stages to consider – the outline, the pattern and the form. These establish their distinctive character and will help you build up a more realistic image of your chosen tree. This process applies whether the tree is ball shaped, or has a layered, or ordered, spread of massed foliage.

in midair so that I become accustomed to their characteristics before starting. It must look strange to any onlooker, but, if it is a means to an end, never mind.

Winter trees

Generally the best time to study the shape of trees is in winter when their trunks, outlines and tracery of branches are exposed and can be observed more closely. These 'portraits' of a single tree are the fundamental skeletal shapes we hang our foliage on, so they have to be correct and recognizable. Study the tree carefully. How does the trunk 'function'? How does it rise from the ground? Does the tree have a 'clean-cut' root system or does it spread its web of roots

about the trunk? What are the markings on the bark like? How do the main branches form the structuring of the tree? What shape is the tree against the sky? All these questions will have to be resolved in your tree studies to bear successful results and a few preliminary sketches will be necessary to determine these facts.

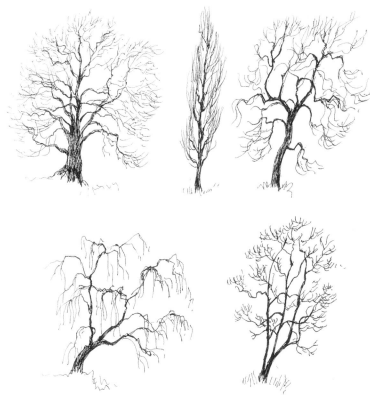

▼ The Old Oak
28 x 20 cm (11 x 8 in)
This is an example of tone, textures and shape, with an indication of background and root study. These observations are important in bringing authenticity to your work.

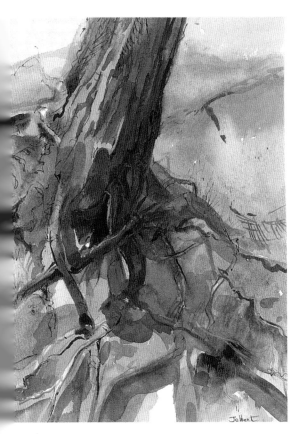

▲ I have illustrated a beech, poplar, ash, willow and alder trees. It is worth trying out a similar series for yourself.

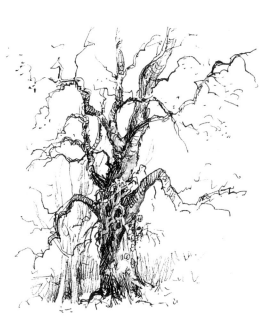

► The Old Oak Tree
13 x 13 cm (5 x 5 in)
This tree is an excellent example of time well spent sketching with a black steel-nibbed pen, discovering for yourself how the structure of a tree works.

31

Mixing greens

Trees hold an interest all year round. Whether with bursting buds, in full leaf, in autumn tints or bare branches, there is a constant wealth of beauty and colour to capture. Do resist the urge to paint every green you can see when painting your tree in full leaf. A single basic green underlying all the greens you create in one painting can unite the picture.

There is a mixture of greens each essentially different for certain trees. For instance, willows are a 'grey' green, adding Coeruleum and Burnt Sienna, while a Scots pine requires a stronger blue, such as Cobalt. An oak in full sunshine will need Yellow Ochre and a touch of Cadmium Yellow.

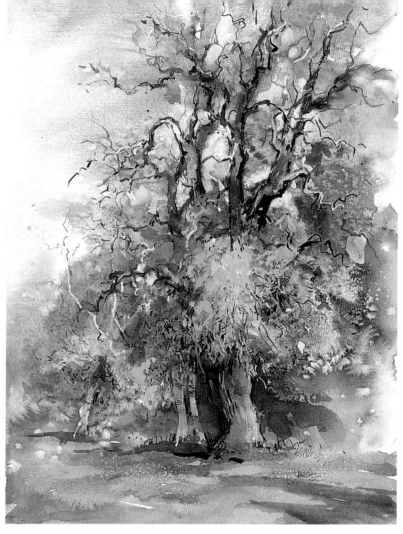

Suggesting foliage

Try simplifying trees by omitting a lot of the individual leaves and massing them together in a 'block' shape. Foliage can be suggested by ink-texturing or broken edges of the massed foliage areas. When you are planning your trees consider carefully what materials you are going to use. *Elm Tree at Urchfont* shown here and *Winter Wonderland* on page 7 are both examples of pictures that use several exciting methods together, including the application of salt.

▲ **Elm Tree at Urchfont**
36 x 25 cm (14 x 10 in)
Salt can solve the problem of depicting large areas of foliage. Add it to the wet watercolour wash and allow it to dry thoroughly before rubbing carefully off the surface afterwards. I added the branches later with waterproof sepia ink.

◀ This flow of colour started with one green – Olive Green – and other colours were slowly added, including Coeruleum, Burnt Sienna, Ultramarine Violet, Raw Sienna, Yellow Ochre and Permanent Yellow. This series of colours makes naturalistic greens and can be added to any basic green. Try using Sap Green, Hooker's Green Dark or Viridian as bases for creating different ranges of green.

Autumn tints

In autumn the trees are clad with a glorious cloak of golds, reds, browns and yellows. I love this time of year as it can reveal glimpses of the tree structure and the dusting of fallen leaves reveals splashes of vibrant colour. Violet used as a distant colour helps with a sparkle and contrast to the yellows and oranges of the season.

It is always a good idea to show something, or someone, that will give scale or proportion to the scene. A figure provides a focal point and gives the picture a story or a reason to have been painted.

▶ Here are some small details of two trees, an oak and a Scots pine, which decipher each tree's essential 'feel', such as the acorns and cones. I made these studies in non-waterproof sepia ink. I used different mixes of Burnt Sienna, Yellow Ochre, Coeruleum and yellow-greens in watercolours and inks.

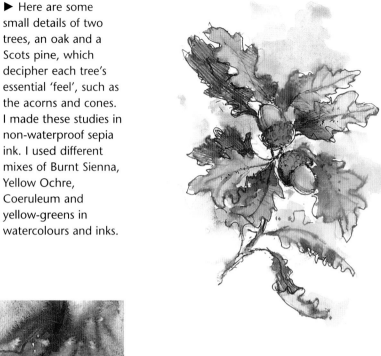

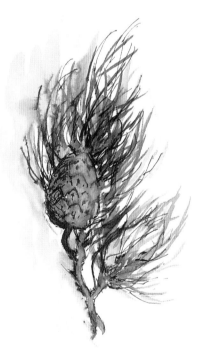

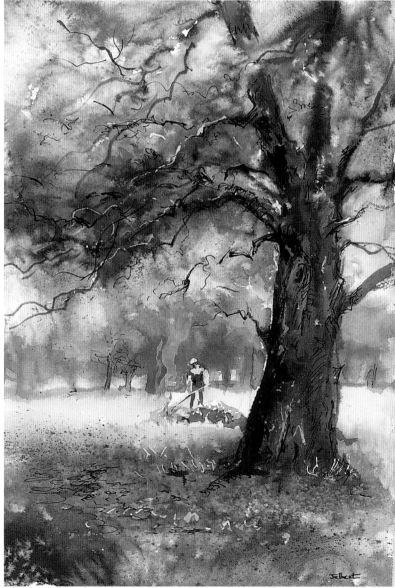

◀ **Collecting the Autumn Leaves**
28 x 19 cm (11 x 7½ in)
Salt was added to yellows, oranges and browns and a bluish distance to denote a wood. I penned in the dominant tree using a black waterproof steel-nibbed pen to define the branches and the texture of the trunk. The smoke was a wisp of white ink and I included a figure burning leaves to show the size of the tree.

33

Flowers and Gardens

Among the most popular subjects for the painter are flowers and gardens. The gorgeous variety of textures such as spiky, feathery or ridged foliage, vast array of pastel, vibrant or transparent colours, and shapes that vary from the domed heads of peonies and dish forms of water lilies to the multiheaded umbelliferous cow parsley are a delight and capture the imagination. Flowers are easily available for study from your own garden, pot or windowboxes, or from just around the corner at your local florist's. I sometimes use silk ones for long studies or classes – no excuse for not finishing a picture because the plants have died!

Basic shapes

You do not need to be a botanist to sketch and paint convincing flowers. Consider their basic shapes and decide to which group they belong, and draw the underlying form first. However complicated they seem, all flowers happily fall into basic shape groupings. Try drawing out a few flower heads for yourself and discover the range of interplaying shapes that occur.

Once you have familiarized yourself with the flowers, try to decide how they are attached to the stalks and the leaves. Are they attached in herringbone fashion, or staggered? What shape are the leaves? Sketch out the plan of the stalk and leaf shapes. Whether you make a pen drawing or use colour washes, the stems have to relate to the flowers. Always pencil in beforehand so you have a gentle guide.

Careful study and time is needed to accompany these subjects, but this will quickly improve your observation. Practise a few speed exercises with different types of flowers, setting yourself time limits.

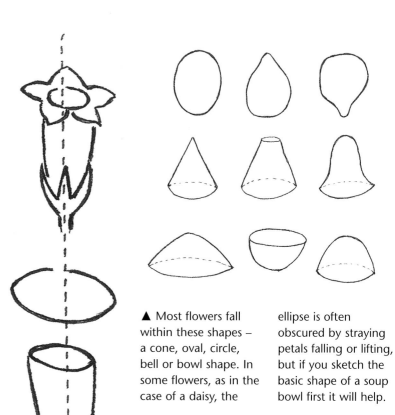

▲ Most flowers fall within these shapes – a cone, oval, circle, bell or bowl shape. In some flowers, as in the case of a daisy, the ellipse is often obscured by straying petals falling or lifting, but if you sketch the basic shape of a soup bowl first it will help.

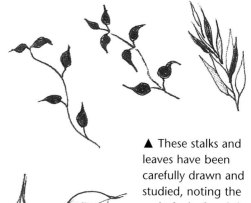

▲ If the flower head is complicated you need to follow a logical 'step-by-step' process. In this bellflower a cup, cone and circle all naturally link into one another. The same applies to a daffodil or fuchsia and many other flowers. I used a steel-nibbed pen for my quick, but bold, sketches.

▲ These stalks and leaves have been carefully drawn and studied, noting the curl of a leaf and the complex shapes it produces. Try making the leaves 'see-through', with the main vein bending and forming the backbone of the leaf. Watch how one leaf crosses or seems to merge with another.

▶ **Hibiscus**
38 x 25 cm (15 x 10 in)
This painting was a
demonstration that I
did for some of my
students on the spot
in Greece. They all
had a go afterwards
with excellent
results. I used
mixtures of Vivid
Green, Carmine,
Alizarin Crimson,
Yellow Ochre,
Permanent Mauve
and Cobalt Blue.

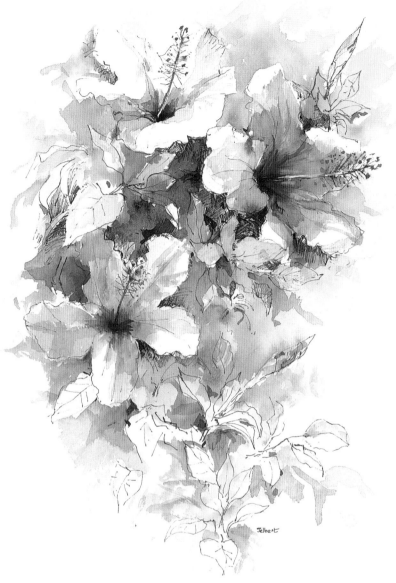

Making a flower study

For spontaneity and lifelike results when making a flower study work from nature. First, look at your chosen flower carefully and decide to which group of shapes it belongs. You may want to include several flower heads in your composition and you can do this simply by looking at the flower from different angles.

Lightly pencil in the flower heads along with their leaves and a couple of buds for added interest. Then I usually draw in the leaves, centres of the flowers and the petals using a sepia steel-nibbed pen for a softer look. I leave some of the outline unpronounced and broken. A series of anchor points of dark ink work threaded through the sketch helps to create depth and recession in the picture.

It is useful to pre-mix pools of the main colours you are going to use so that you avoid delays that would interrupt a wet-into-wet approach. Much of the naturalism of flowers can be captured by using this technique, so wet the flowers first and then drop colour into the centres and buds and let it bleed. If you are painting pale petals it is effective to wash in a warm colour such as Yellow Ochre and a cool colour such as

Cobalt Blue to give depth and to portray reflected light on the petals. Remember to keep parts of the petals as white paper. Paint the flower heads first as you cannot paint flowers over stems and leaves afterwards.

When the paint has dried wet the remaining area of background and add leaves in trails of greens to link all the flower heads. A 'C' shape that runs from the top to the base of the picture often works well. Then mix darker greens and place them in the shadowed foliage behind the flowers to highlight their shapes. A little mauve added to the flowers and leaves helps to give extra shadow and depth.

Counterchange

Every successful picture including flowers has a 'counterchange' of tones. This simply means a juxtaposition of dark and light, or light and dark, and these balances of contrast give exciting depths and patterns to your work. Once you have discovered this principle you will find it everywhere. It is fascinating to look for the underlying changes in other painters' work and to discover how you can use it to good effect in your own pictures.

Experiment by dividing a piece of paper, covering one third with waterproof black ink and leaving the other two thirds white. Then, with a few pen doodles, compose a variety of forms – say, plant forms – placing white ink in the black area and black ink in the white area. The composition will begin to piece together, and you will discover how much you need in one area to balance out the other.

Counterchange using colour

If you see something that gives you a strong visual experience this is the time to translate your emotions and the dramatic impact of

▶ The technique of counterchange is used extensively by great artists, setting light objects against dark and vice versa. I used the same leaf study throughout, but as the leaves become set against the light background they are darkened, and as they trail against the dark pot they are lightened.

the scene rather than trying to reproduce the subject exactly. Here counterchange comes into play with the interplay of 'colour counterchange', using warm areas of colour (such as orange and yellow) against cool ones (such as blue and mauve), with their intensity of tones that balance light against dark to the limit.

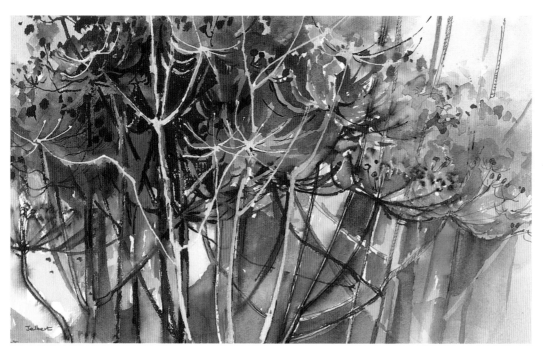

◀ **Cow Parsley Fields**
20 x 30 cm (8 x 12 in)
Here Spring is heralded by a study of Cow Parsley in pen and wash. Using masking fluid for the light patterns and black inks for the darkest patterns, I was also aware of how the coloured forms highlighted and enhanced this complex web of counterchange.

Coloured inks

Vibrant and vivid, coloured inks are ideal for brightly coloured flowers. Using the ink neat, or without much water, gives an intensity and brilliance that is hard to match in any other medium. Different types and makes of inks can be mixed together (but experiment first!) and they can be thinned with water and overlaid in use.

The combination of subtle tone work with strong or overpainted translucent washes gives really interesting possibilities for flower painting, with some areas running and others remaining stable and separate. Apply the inks loosely wet-into-wet using a size 8 flat-headed brush for large areas.

◄ **Nasturtiums**
36 x 30 cm (14 x 12 in)
I used a mixture of drawing and acrylic inks, overlaying many of the washes for the hazy distance. The flowers were worked wet-into-wet with a flat-headed brush size 8 and a rigger size 1, with a ruling/drawing pen for finer details.

Gradually work in more definite shapes with a smaller brush as the inks dry to avoid them running or fusing. A size 1 rigger is also useful for denoting the shapes of petals, leaves and tendrils. Add suggestions of fine detail with a steel-nibbed pen or ruling/drawing pen.

If it is essential to capture a vibrant 'glow' place a quick initial yellow ink wash over the area and let it dry before starting the actual picture.

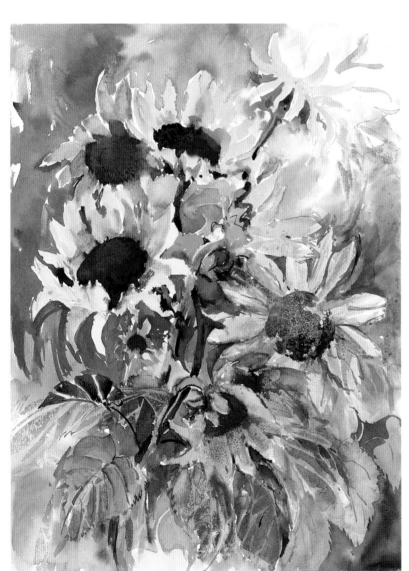

◄ **Sunflowers**
43 x 30 cm (17 x 12 in)
I painted these blazing flower heads using a brush first, with a number of different inks in yellows, oranges and sepia. While they were drying I wetted the background area and ran in blues, purples and greens for the distance and leaf structures, letting the colours bleed. I outlined some of the stems and leaves with a smaller brush and put in details in the flower centres with a steel-nibbed pen.

Garden features

Once you have mastered a composition of flowers it is likely that you will want to place them in a setting of some kind. Garden views offer a wealth of subject matter and allow you to combine interesting features, such as a wall, an attractive pot, a rustic pathway or an arch, with yet another balance of textures and colours. I have spent many a happy hour sketching alternative settings for flowers.

A good exercise, once you are happy that you have rendered your chosen flowers correctly, is to place them in two different situations. This will certainly get the imagination working overtime! If you find an imaginary garden setting too daunting just sit outside your back door and paint the flowers you see. I often use photographs of my favourite garden corners as reference in the winter months.

Masking fluid is useful when working on a garden scene as it allows you to reserve highlights and general suggestions of shapes. A helpful tip is to add white ink or gouache to a sunny yellow for foliage patches that seem to have lost their glow.

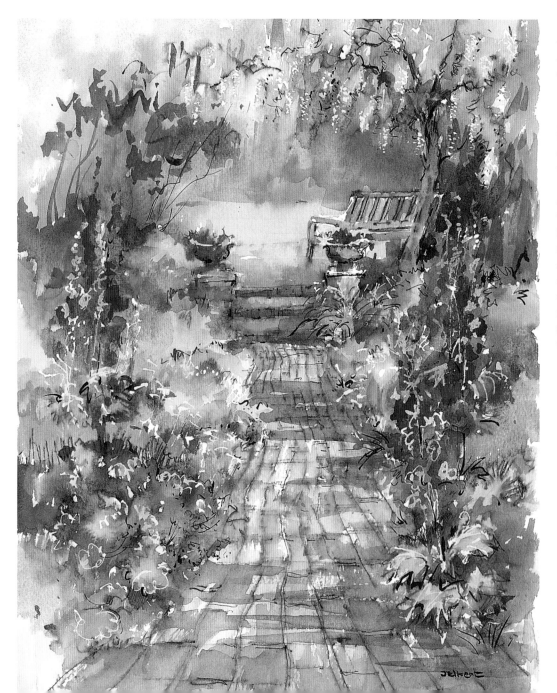

◄ **Garden Scene**
41 x 30 cm (16 x 12 in)
After drawing some details of the bench, urn and path in black non-waterproof ink, I placed masking fluid in the laburnum, delphiniums and foreground foliage. I mixed pools of coloured inks and wetted the surface before starting so that each colour would diffuse. When dry I drew in finer work with a black steel-nibbed pen to define some of the details of the garden.

► **Arch with Potted Geranium**
20 x 15 cm (8 x 6 in)
A formal arch, softened by foliage,

makes an ideal frame. A non-waterproof sepia sketching pen diffused the rather stiff appearance.

Using the background

The atmosphere of individual gardens is enchanting to capture, whether orchards, walled gardens, kitchen gardens, or formal ones in parks. Just beware of parks – artists at work in public become sitting targets for the curious!

Often, however, it is only too easy to concentrate on the flowers and not observe their surroundings fully, forgetting the real charm of the scene. To help with composing the scene in front of you start your picture by immediately placing a hint of the background. This gives some purpose and stability to the plants and you can complete it later on. The background needs to play both a 'flattering' and a supporting role by placing your flowers in some kind of setting.

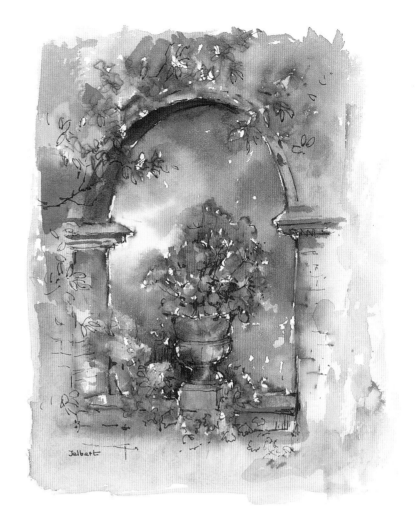

◄ **Walled Garden**
23 x 30 cm (9 x 12 in)
In this picture simple watercolour washes are used with delicate, but detailed, pen markings and texturing. I mixed the deeper tones of watercolours with denser pen work to enhance the dark shadows on the wall and foliage behind the foxgloves. This produced some good contrasts when I used a translucent yellow wash for the mid-distant grass area.

Water and Boats

Water holds a deep fascination and magnetic attraction for artists. Lakes, rivers and the sea have provided inspiration for centuries and captured reflections add a new dimension to a landscape or seascape. Moving water can be the source of very beguiling patterns as the play of light creates flowing lines and shapes. The reflections still remain vertical but they may be lengthened, with the image becoming more shattered as movement becomes increasingly evident.

The more you look, the more you will understand how to portray this subject. Remember that water usually has little colour of its own – it depends on reflected colour from the sky or scenery around it or the subject matter in your picture. When you are trying to work out the movement of water, make notes in your sketchbook and watch until you discover a personal way of depicting the particular conditions.

Building up tones by combining line and wash is ideal for rapid and free work when sketching on the spot and means that you do not have to concentrate on pen alone to provide the tones. You can also produce expressive drawings using varied lines with defined ink washes, a technique which is particularly suitable for seascape subjects.

▼ **Chesil Beach**
18 x 13 cm (7 x 5 in)
I used detailed pen work for the foreground pebbles, and simplified the 'massed' look as they met the horizon.

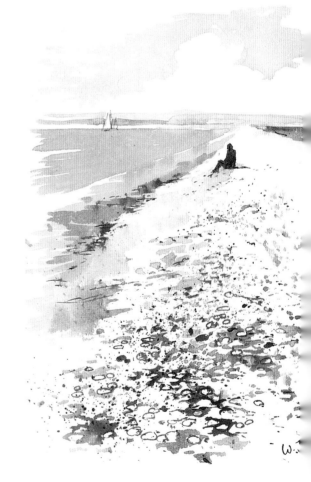

▲ Reflections are a continuation of the object. For reflections on a flat surface keep the movement of the water simple by gradually widening the ripples and the reflections to create distance.

▲ The elements, particularly light and wind, play an important role in shaping reflections. Emphasize roughened water by breaking up the linear perspective lines with stabbing and disjointed marks.

◀ I studied the boat very closely, turning my sketch upside down to compare its mirror-like reflection. When painting reflections, notice that they are often darker than the object.

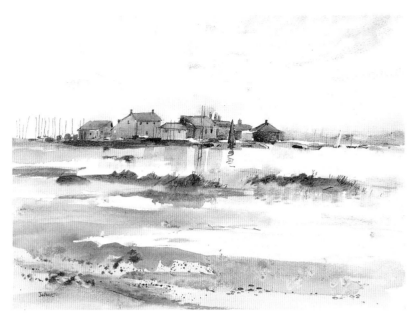

◀ **Milford on Sea**
29 x 39 cm (11½ x 15½ in)
I painted this in situ on a lovely sunny day. The 'rhythm' of vertical lines leads to the focal point of the dominant building with the red sail reflected beside it. The Coeruleum sky is reflected in simple areas throughout the study. I used a sepia ink with a ruling/drawing pen for detailing.

▼ **Dedham Reflections**
28 x 38 cm (11 x 15 in)
The reflections were exaggerated by zigzagging the image and adding swirling lines on the water. The trees grow back from the water's edge, with their reflections cut off by the bank. See how much of the larger trees are lost; the tree nearer to the water's edge loses very little.

Atmosphere and conditions

Painting water and reflections is difficult, but no more so than any other subject. It is necessary to observe the overall weather conditions and their relationships to water – try to understand the underlying patterns. Water reflects everything about it, so the tone and colour of the sky will be in the water. Enthusiasm for the scene is essential, but beware – without some discipline there will be frustration and confusion. Study your subject and make some key sketches. Observation will improve your work.

Working outdoors

Here is a quick checklist that will be helpful in starting any seascape or, indeed, any outdoor scene:

1 Choose a subject that 'grabs' you, and pinpoint your starting or focal point – the reason for the painting. The composition will then fit around that point.

2 Feel an emotion for the scene. Think carefully about the placing of objects within your composition and the use of 'line' or 'arrangement'. Rising lines create joyful feelings, straight horizontals are relaxing, while verticals are stable and unmoving.

3 Consider the general atmosphere and its colour. Is it overcast, sunny or misty? The range of colours you choose will govern the atmosphere. Is it going to be predominantly blue, for instance?

4 Balance the tonal values. Check that the light, medium and dark areas are well balanced so that they meet and fit snugly into one another like a jigsaw puzzle. The darkest and lightest points need to be near the focal point.

Boats

Know your boats. If you are hoping to place a boat in a picture it is vital to know what sort, type or shape you are looking at. You will need to portray the angle, how it is built, and how to settle it into the water. One should draw boats continually to achieve the confidence that eventually comes with hours of practice. When you next visit a collection of boats, look at how they are constructed – do they have a point shape at each end, or a flat stern? Are they made of wood, or fibreglass? How are they constructed?

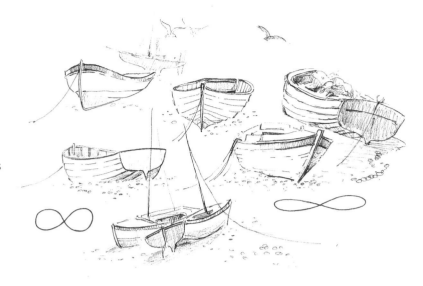

Colour and movement

A quick way of recording the essence of a boat with some impact is to use a 'glow' of colour and plunge it into the reflected water surface before it dries so that it bonds visually with the boat above. A quick pen and wash sketch will establish the general setting, but a more detailed study of the individual boat will be required if it is to be painted with confidence later. Many aspects can be resolved at this sketch stage, but you may need to work quickly as the scene can look quite different when the tide turns.

Photographs are a useful way of capturing the look of moving water and allow you to make numerous studies at your leisure. Squiggles of penwork and washes of colour waved through the water will give movement and sparkle.

If you need to use information for a reflection that seems unclear or blurred in a sketch or photograph, place a mirror against the underside of a boat or figure. This will give you an exact image to paint from. You can then add broken lines across the reflected object and 'wiggle' the water's surface around it.

▲ A figure of eight helps to form the basic structure of a boat, and it appears to flatten as you lower your eye level. Try drawing boats at different angles and then perhaps two together.

Keep your masking fluid safely on location in a small watertight capsule such as an empty film container.

◄ **Boats at Bosham**
28 x 38 cm (11 x 15 in)
Here the hulls are highlighted as assorted silhouetted shapes against the light stretch of water.

Choosing a sea subject

The seaside holds a myriad of treasures – the sea itself; dramatic cliff tops; receding tides revealing wet sandscapes; storms battering rock faces into exploding foam and spume; huge scuttling clouds reflected in wide, moody seas, perhaps with sails dotted in the distance; or, nearer, the interiors of boathouses and beach huts with their profusion and angularity of detail; or harbour edges, enlivened by the flight of seabirds and their stance on boats, lobster pots and buoys. All these are a delight for artists. Even closer at hand is the plant and animal life on the seashore or in the rock pools. A small area of carefully drawn detail is just as rewarding as a larger study and a magnifying glass will reveal a world of beautiful patterns and structures.

Include in your sketchbook a variety of these studies ranging from panoramic landscapes full of drama, moods and a sense of space through observational studies of boats, seabirds or boathouses to small, detailed close-ups. Try to avoid heavy, uncompromising lines, but build up your subject using dots and a series of light experimental strokes, strengthening those that appear correct and eliminating the others. Mark out the studies on rough paper and only transfer them to good-quality watercolour paper when you are satisfied that the sketch is correct. If you draw over the sketches with ink the pencil drawing can then be rubbed out before you add a wash.

Remember, however, that the sea can be a dangerous place. Paint where it is safe, take care on slippery, hazardous rocks and make sure the tide is out.

▼ **Del Quay, Chichester**
23 x 33 cm (9 x 13 in)
This painting was a hybrid of several sketches and photographs. Underlying the whole picture was a soft Burnt Sienna wash, which I let dry before working in more watercolours. The pen work around the hulls, some of the rigging and mooring ropes helped to tie the picture together.

Buildings

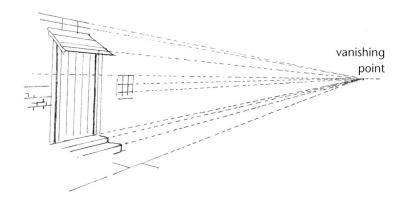

Whether you are interested in architectural styles or simply in quick sketches of village or man-made city environments, buildings provide a wealth of exciting varied scenes.

It is often thought that buildings are a specialized subject and the word 'perspective' is enough to cause the alarm bells to ring. Most of us know that linear perspective is based on mathematics, but it is not necessary to be a mathematician to understand the basic principles, one of which is to ensure that vertical lines always remain vertical. Without the correct use of perspective it would be impossible to create the illusion of our three-dimensional surroundings on a flat paper surface.

Vanishing points

The place where the parallel lines from a building (or part of a building) meet in the distance is called the 'vanishing point' for the obvious reason that they disappear from sight here on an imaginary line called the horizon. The horizon is at your own eye level. When you sit, or stand, your eye level changes and so does the horizon, the direction of the parallel lines and the vanishing point. That is why it is important to stay in the same position throughout when deciding on the viewpoint for a particular building. When I start to sketch a building I immediately place in my eye level so that I can plan the perspective correctly.

vanishing point

▲ I placed in my vanishing points that included the bricks, porch, steps, door and window. Notice the care taken over the number of bars in the window, the steps and the size and angle of the bricks – each has a vanishing point.

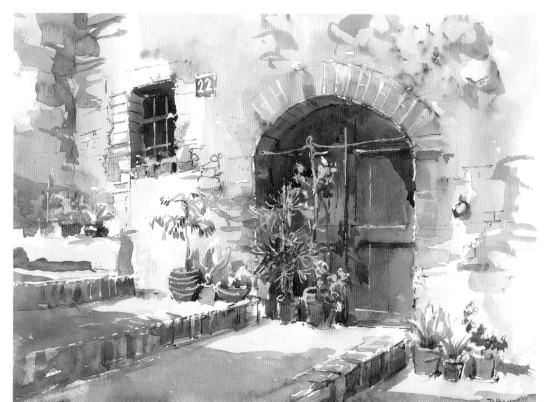

◄ **Tuscany Doorway**
23 x 32 cm (9 x 12½ in)
I sketched and painted this scene using a steel-nibbed pen and watercolours. The centre of the door and all the lines of the steps, door, arch and window meet at a vanishing point, creating a stable relationship with all the elements involved.

You will be surprised how you can misjudge or distort a building feature without realizing it is happening. Do make checks every now and again, especially if you notice something that does not look right. Hold your pen or brush at arm's length against the offending angle and re-establish a receding line or edge. I often do this brush or pen test before I start and accustom myself to the varying and beguiling angles in front of me. The whole operation is not so daunting when you are aware of the dangers ahead.

Scale and proportion

Proportion is as important as perspective – sometimes even more so. Perspective makes the picture look realistic, with solid buildings that are not about to keel over. It is the well thought-out proportions that give the character and scale.

The importance of the size of windows and doors and the heights of roofs in relation to walls is surprisingly often ignored. A carefully planned proportional balance is essential whether you are drawing a barn or cottage, church or palace. The characteristics of every detail need to be taken into consideration and 'measured' to create a convincing portrait of your subject.

Start with one feature, using that as your standard measure, and work through from conception to completion. Relative sizes can be measured by taking a read-off from one part of the building to calculate the proportions of the remaining parts. Work out the height of the building in relation to the width, the proportion of wall to roof, and the number and size of windows.

◄ Here I calculated each proportion to the size of the height of the window, using 'a' as the standard measurement. Often steps or other features can be a quarter or half the original proportional size, as in the steps in this illustration.

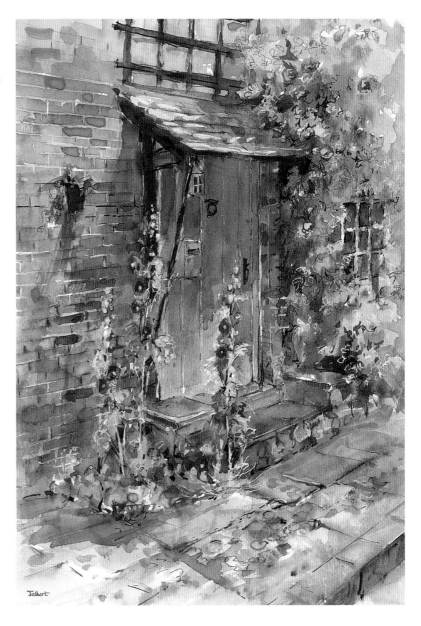

▶ **Blue Door, Itchenor**
39 x 29 cm (15½ x 11½ in)
This doorway allowed me to explore contrasts of shape, colour and texture. I used masking fluid on the plants, then placed in several textures in non-waterproof sepia inks, which bled. All the vanishing points will meet far off the page!

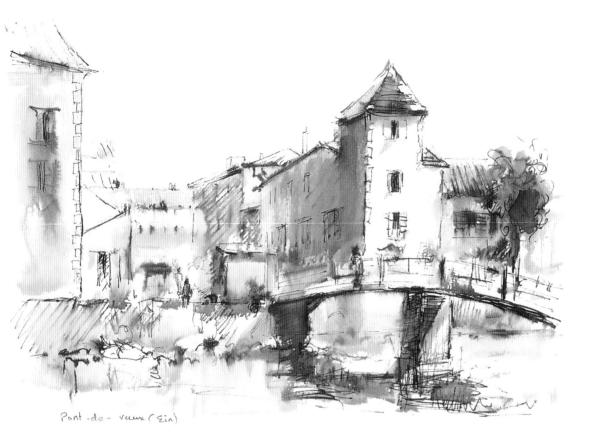

◄ **Pont-de-Vaux**
18 x 25 cm (7 x 10 in)
Buildings can add
authenticity or
'flavour' to a scene.
I sketched this bridge
with assorted-shape
houses in France using
a non-waterproof
sketching pen and
water. Remember
that the laws of
diminishing size mean
the spaces between
windows and doors
become smaller as
they recede.

Pont-de-vaux (Ein)

Working on location

Making a series of drawings from location
sketches gives you a chance to adjust the
visual information you have gathered,
combining the elements of perhaps two
sketches and a photograph to compile a
finished work. These amassed stores of
information and notes should hold a wealth
of crucial facts that may be interpreted when

needed, conjuring up atmosphere and a
convincing 'sense of place'. They need to be
sound and accurate and reflect what you
have seen.

When working on location, keep all your
equipment simple and light. I have a
sketching stool that forms a haversack. This
leaves my hands fairly free for photography
and a quick sketch 'on the hoof'!

I carry a sketchbook that measures
approximately 20 x 25 cm (8 x 10 in), a
300 gsm (140 lb) Not surface Langton
watercolour pad about 20 x 30 cm
(8 x 12 in), assorted pens and pencils, an
eraser, a small portable watercolour box,
brushes and a water container. I also take
a camera, a sunhat and a raincoat. Other
essentials are a Thermos flask or drink and
a packet of biscuits!

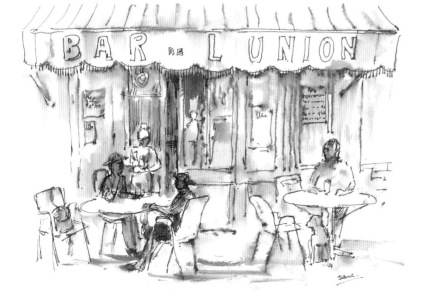

◄ **French Café**
20 x 28 cm (8 x 11 in)
The building acts as a
setting for the people,
with the café giving an
essential flavour to the
scene. Remember that
the placing of the focal
point is crucial. Here
the darkened seated
figures at the round
table, with the
waitress highlighted
in the doorway, create
the focal point.
People give scale as
well as atmosphere.
and life to a picture.

Angles and contrasts

Buildings can be feasts of shapes and colours and do not need to be tightly detailed. Before you start drawing any building note the angle of the roads and pavements on which it is placed, and the angles of the roof, windows and doors. Note how steep or slight each slope is and suggest this by mapping out a line of dots, which you can join up to form a network of carefully thought-out structures. I also take several photographs from different angles to gather all the relevant and accurate information that I may need.

The contrasts of buildings set against landscapes are exciting. Buildings set against a skyline cut into the sky shape and this in turn sets up more shapes and patterns. If you find perspective too complicated just sketch in the skyline shape and the pavement shapes and you will discover the building shape left between them.

It is vital to note how and at what angle the building is lit from and how the details fall into assorted 'planes'. Whether these areas are highlighted or in shadow gives form and convincing presence to the building. It is valuable to quickly form blocks of tone with sketches to explain the 'layout' of your chosen building.

Making several coloured sketches always whets my artistic appetite and composing several thumbnail sketches into a choice selection of pictures is certainly challenging.

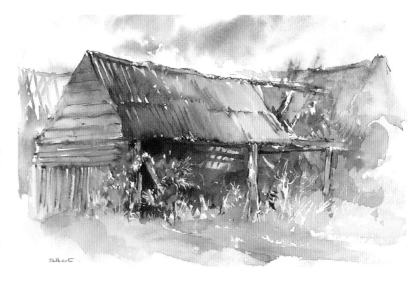

▲ **The Old Barn**
18 x 25 cm (7 x 10 in)
My interest was in the lively patterns of this old decaying barn. The other buildings created a dramatic, but simple, background to these abstracted shapes.

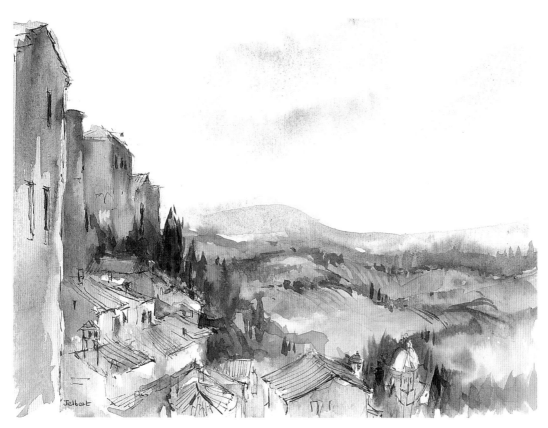

◄ **Tuscany Rooftops**
20 x 28 cm (8 x 11 in)
I used a sepia waterproof steel-nibbed pen, sepia felt-tip pens and watercolours. The background was in watercolours, with a little felt-tip moulding into the field patterns. I outlined the roofs and the buildings to highlight their textures and shapes, creating a powerful foreground and forcing the hills into the blue distance.

People

The saying that 'if you can draw people you can draw anything' reflects the fact that figures are one of the most complicated of all subjects. It used to be recognized that part of an art student's basic training was studying life drawing. Nowadays there is less emphasis on the figure, and therefore more difficulties arise when confronted with this challenge! For many aspiring artists the thought of including figures in a picture is daunting. This is a pity as figures put life into a landscape, give a sense of scale and are in themselves an absorbing source of study.

Any fear of painting figures can be overcome by plenty of practice and keeping the subject simple. Whether they are to be used in the middle distance or as a main subject, you need to focus on what they are doing rather than who they are.

The structure of the human face differs according to age, sex and nationality, but the basic proportions remain the same.

Figures in motion

A few lines are all that is necessary to capture a sense of action. Beginners often joke that their figures look like 'stick' people, but you can turn this to advantage by developing the shape of an active figure into a simplified 'stick' study, enabling you to work at speed.

When you observe people moving you will become aware of the many different positions the human form can assume. Using a sketchbook to record people, whether in action, working or at rest, will be a valuable exercise as these quick sketches can be a useful aid when you are composing a larger picture. These figures may become the perfect focal point.

▶ The diagrams show that the head and trunk make up half of the body and the legs the other half. The head 'fits into' the body approximately 7.5 times. Men's shoulders are wider than their hips, but the reverse is found in women. Every human being is an individual, so these are only rough guides. A baby's head is large in proportion to its body.

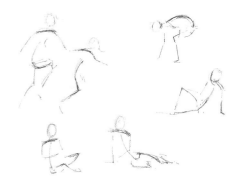

◀ When you first start drawing people who are repeating the same action, look for the direction of the main 'lines of motion' that run through the whole body. You can build up information later on to make a complete study.

▶ **Fishing**
15 x 15 cm (6 x 6 in)
A small study in mainly watercolours and a little ink. A tilt of the head, the line of the body or angle of the limbs, all poised for potential movement, suggest that a figure is 'geared for action'. The 'line of sight' is crucial so you are aware of the centre of interest.

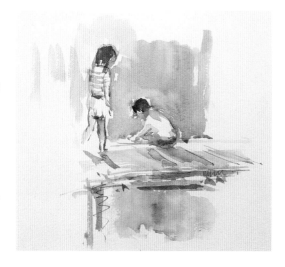

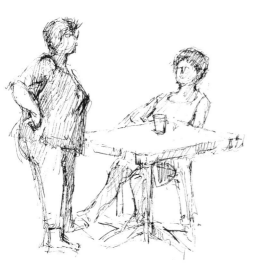

▲ Whatever kind of garments your subjects are wearing, try to visualize the body beneath. Analyze the pose. Measure carefully and draw light guidelines to indicate key points and proportions.

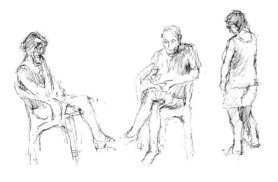

◄ I love to study my students at work lost in another world. They have individual characteristics of pose and dress. A steel-nibbed pen or ballpoint pen enables you to work quickly in both line and tone.

Drawing people with confidence

If you have practised drawing your 'stick' people it may be time to take up the challenge of studying them in more detail. Family and friends are always ideal subjects, but you need to work fast while they remain unsuspecting. Once they discover what you are up to they may become self-conscious.

Drawing animals alongside your figures can be both frustrating and rewarding. Unfortunately, they are not the most co-operative of models as they tend to move or walk away. I always do a quick sketch of the animals separately and then add the figure, often making one study over the other, and not altering anything until later on.

As with any other kind of observation, the secret is in your own determination not to be put off with failures. You may find it difficult to achieve successful on-the-spot sketches at first and it will certainly take some practice to be able to grasp the essentials in only minutes.

Do persevere – a good sketch often says more than any amount of finished detail.

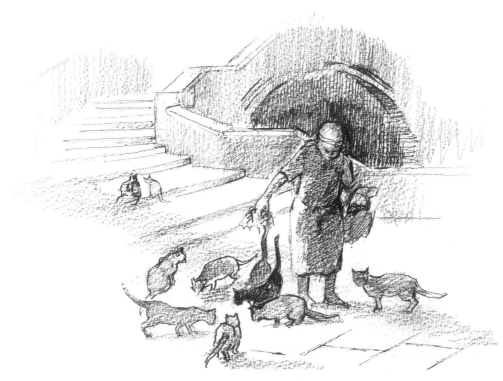

◄ **Feeding the Cats in Venice**
18 x 25 cm (7 x 10 in)
To capture the stooped figure of this old lady, I used a black ballpoint pen and 3B pencil, starting with a curve (for her back) and then built upon this shape. I introduced the darker patterns in the background, which highlighted the figure, and composed the cat shapes into a counterpoint against the lighter steps.

Populating your paintings

The magical results come from your hard work when you transfer sketched figures into a setting of some kind. You need to establish a convincing environment and place everything with some feeling of correct scale. It can be great fun working out these new 'homes' for your figures and, with a little effort in composing some thumbnail sketches, they will appear natural and relaxed. In many cases a successful group or a single study can be placed in a variety of new surroundings.

In my studio I have compiled a file of news cuttings, magazine studies and photographs so that I have the reference to add an extra figure if required. Equally, you could take away a figure as long as the group remains balanced and natural looking.

> Always place an initial 'matchstick' man study in pencil for your figure drawings before starting to add the pen work.

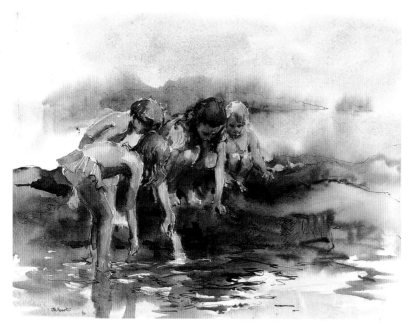

◄ Rock Pool Reflections
25 x 36 cm (10 x 14 in)
This picture is the result of some changes. Even so, if the boy figure at the back was removed the group would remain a successful composition. Zigzagging the pen and watercolour lines under the figures gave depth and movement in the water.

▲ Tuscany Café
28 x 20 cm (11 x 8 in)
This is a very active picture, with people coming and going in this colourful alleyway corner café. To capture the feeling of constant action I used a non-waterproof art pen. The diffusing quality gives an atmosphere of transience and flecks of bright watercolour produce a festive look.

◀ In this photograph my students are delightfully involved in another work, collecting together in an excited group. They make a good, interesting subject.

▶ I experimented with the lighting, using a black steel-nibbed pen, by crosshatching a variety of loose lines to depict a sun-drenched light background that slightly diffused the darkened figures. I drew an arrow to remind me of the source of light.

Gaining more confidence

As your confidence grows you will be able to tackle more complicated situations and attempt likenesses of friends or sitters. When time is at a premium, freshness and spontaneity are essential. I usually photograph the scene immediately and then back it up with sketches. In this case the need to see faces in great detail is unnecessary, but jot down glimpses of spectacles or a beard or some indication of individual characteristics. Do not become too involved in minor points.

Here is an exercise you may find interesting to try out choosing your own subject matter. Select a photograph of several figures, then swap or change them about, keeping the emphasis on what they are doing. Remember you need to retain the characteristics of each person.

I try to photograph people while they are unawares, then often reconstruct the scene afterwards in an altered format using sketches. You may be struck by the dramatic changes of sunshine playing on a group that could be changed into a bleached highlighted effect or a darkened silhouetted alternative. Such moments in time are frequently so brief that you may have time only for a quick accompanying scribble. Devoid of any details, your sketch should concentrate on the basic characteristics of each person. Note down the direction of light in the form of an arrow so that your figures will be consistently lit.

▲ Using a sepia water-soluble pen, I reversed the process. I darkened the background, which haloed the figures and forced strong shadows connecting the group to the artist on the right. Shadows can be improvised, even if the sun has momentarily vanished.

Storm

To capture one of nature's dramatic moments is indeed a great privilege. I tried to evoke the force of the approaching storm and feeling of distances by placing in the foreground foliage, the slithers of lights and darks and the shaft of sunlight to create this mood. Black Quink ink gives a range of colours when diluted with water.

▶ First stage

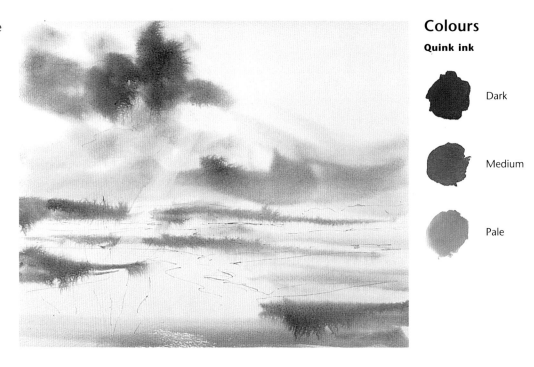

Colours

Quink ink

Dark

Medium

Pale

First Stage

This entire scene uses wet-into-wet technique. Having sketched in the basic drawing of the sky, cloud formation, mud flats and shore with a 3B pencil, I washed over the whole surface with clean water, using my largest soft watercolour brush. I then washed a simple mix of very watery Quink ink into the shadow areas, and across the bottom of the sky, then into the land areas. I immediately 'wiped out' a central shaft of sunlight through the clouds with kitchen paper. This had to be done well

before the ink started to stain or to dry. Sometimes it is advisable to add an immediate pale wash back up against the shaft of light if you have overdone the initial highlighting effect or you need to emphasize the shaft of light more fully.

Second Stage

I continued to work in 'wet-into-wet', forming the darkest areas of clouds, darker mid-distance and areas of mud flats, using a slightly darker Quink ink wash. I carried the sky washes up to the streak of sunlight, so

emphasizing the feeling of light. Using a smaller brush, I outlined the landscape and began to darken the foreground features to enhance the three-dimensional look.

Finished Stage

I used horizontal brush strokes to complete the water area, painting in soft tones with much water – this allows the lovely separation of the yellows and blues from the black ink. Using water alone, I repainted the sky and distance just to soften any harsh areas. I darkened in the background to emphasize the hills, and let the surface dry before adding the final details.

Using a ruling/drawing pen and neat Quink ink, I drew in the finer details of the grasses in the foreground. I stood back to check the effect, waited to let some of the ink dry and then decided to use a little water to combine the soft and hard lines of the final details to finish.

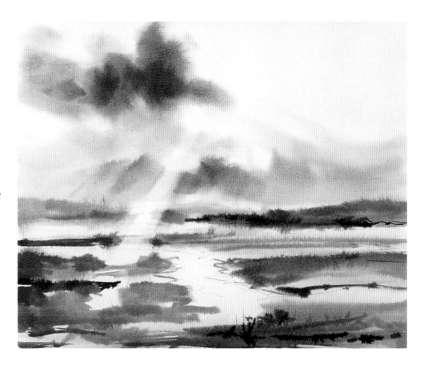

▲ Second stage

▼ **Storm**
30 x 38 cm (12 x 15 in)

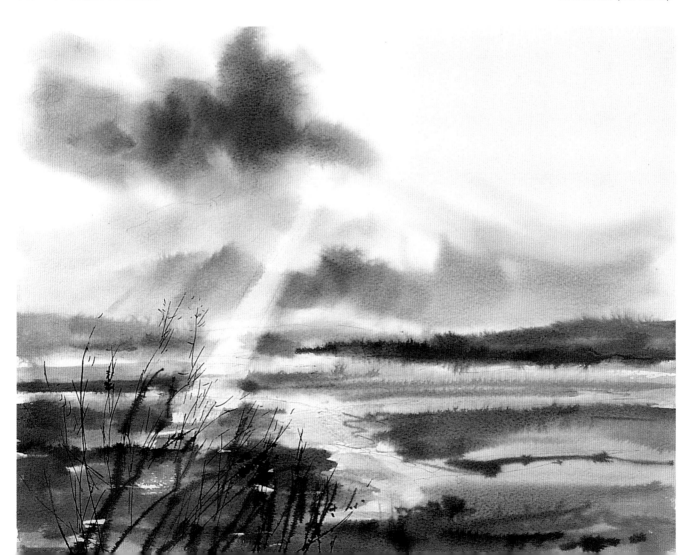

Geese at Farmhouse Gate

I always find farmyard corners intriguing to sketch and paint. There is usually something happening or an interesting subject to be found – whether it is animals or birds visiting, nesting or rummaging; wonderful weeds intertwining around a rusting piece of machinery; or part of the farm building with decaying woodwork or peeling paint. All these are asking to be painted.

▶ First stage

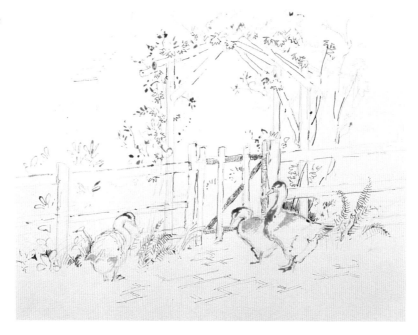

Colours

Artists' watercolours

 Ultramarine Violet

 Cadmium Yellow

 Bismuth Yellow

 Cobalt Turquoise

 Raw Umber

 Burnt Sienna

 Hooker's Green

 Cadmium Red

First Stage

I worked from two photographs and planned my composition from thumbnail sketches. A farm can make an ideal backdrop to a chosen subject, especially if you use it as a darkened silhouette to prevent the scene looking too cluttered or detailed. I drew in the details of the gate, farmhouse and geese using a soft pencil, then detailed with crosshatching, using a sepia waterproof steel-nibbed pen size 0.1. I applied masking fluid to the light areas. Retracing my first lines, I added heavier ones for the tops of the gate and fence posts.

Second Stage

To give a pervading atmosphere of sunlight I applied a watercolour wash of Bismuth Yellow and Cadmium Yellow with dabbing, flowing strokes over the foliage and masked areas. I added a little Cobalt Turquoise for a greener, shadowy tint to some of the leaves. Foliage needs hard and soft areas, so I filled in between the gateposts with an assortment of light and bright yellows and greens, dabbing out with kitchen roll if too dark.

To brighten the scene I mixed a touch of Cadmium Red to make orange and added this as an underwash for darker areas on the

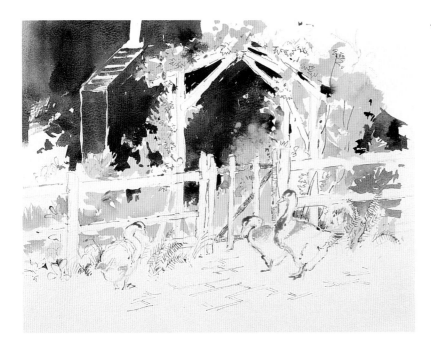

◀ Second stage

right and lighter ones on the left. Reds and oranges add sparkle and contrast to large areas of green.

I half-closed my eyes and decided that the farmhouse building had to be bold and dark. I used Burnt Sienna and Ultramarine Violet for a 'velvety' background. A little Cobalt Turquoise was added to this mix for the left side of the angled walls and the doorway recesses. A darker mix (more pigment of each colour) was needed in the building, accenting odd corners and thus highlighting the foliage near the gate.

Third Stage

The sky was suggested by a watery wash of Cobalt Turquoise, also added into the green mix for the distant trees. I added Bismuth Yellow for a heavier mix for the foreground, grasses and foliage around the gate and into the background. I mixed Hooker's Green and Cobalt Turquoise for the foliage on the right of the arch, with a little orange to dull down the colour for depth.

I paled Cobalt Turquoise for the fence posts and arch, adding Ultramarine Violet for the shaded parts and Burnt Sienna for the deeper areas on the gate. These abstract shapes would contrast with the sunlit areas behind, and highlight the geese. I added

Burnt Sienna to the green mix for the foliage around the geese shapes, with a darker mix for the undershading near to the fence, using diagonal brush strokes to denote undergrowth and grasses. Watery Burnt Sienna was washed into the foreground area.

Orange and yellow were then mixed for the two geese on the right and Cobalt Turquoise for the one on the left. More blue gave structure to their forms. I added orange to beaks and feet.

▼ Third stage

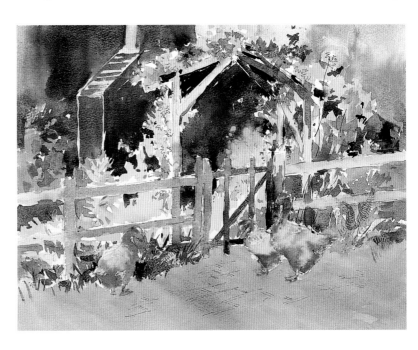

Finished Stage

I darkened the right-hand foliage over the arch, fence posts and foreground grasses with different mixes of Hooker's Green and Cobalt Turquoise.

I rubbed off the masking fluid and washed over the whitened foliage areas with Cadmium Yellow. The white geese were painted with pale yellow, keeping the lightest area on the right-hand goose as the focal point. Burnt Sienna and Ultramarine Violet were painted for darker shadows on the geese to place in rounded breasts and wings, and a little more turquoise for the lower part of the wings. Legs and feet were darkened with orange.

I mixed Burnt Sienna and Ultramarine Violet, loosely washing over the paving stones around the arch and geese, with dabs of thicker pigment to darken even further around the geese. For darker shadows I mixed more Ultramarine Violet and Burnt Sienna and covered loosely around the gate, background of the geese and the shadows cast across the foreground, forming lovely patterns over the stonework.

I detailed the foreground more fully with sepia pen work, accentuating with small areas of ink lines. I also dotted in the eyes of the geese, added small details on the beaks, and loosely sketched around the legs and feathers. More foliage details were added in pen to the edges of the arch, and darker negative shapes and foliage patterns defined around the arch.

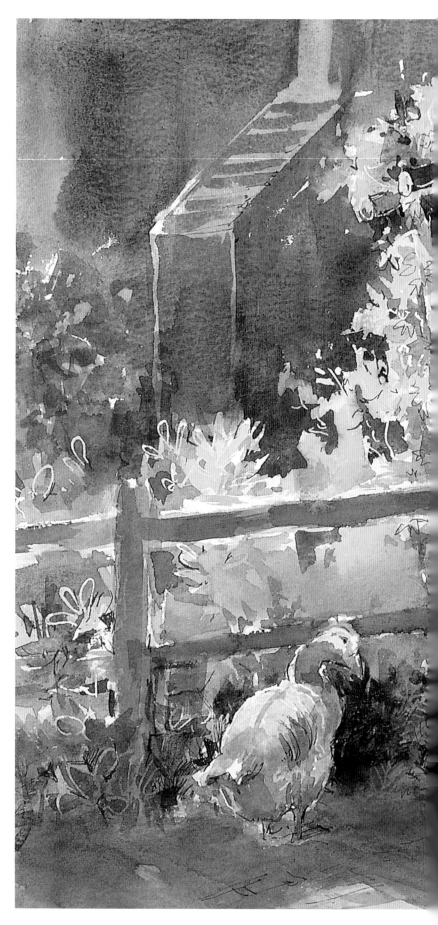

▶ **Geese at Farmhouse Gate**
30 x 39 cm (12 x 15½ in)

56

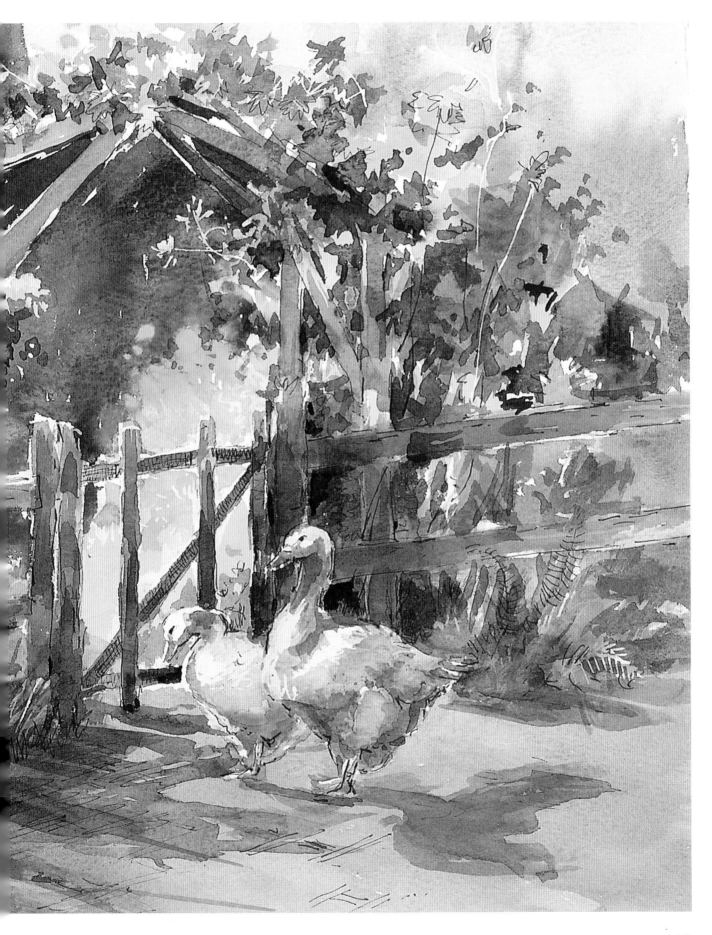

Children Crabbing

This small corner of humanity was exciting as there was a mix of ages, all lost in their own activities, with the light from the right linking the figures while being reflected wonderfully in the water. When sketching people engrossed in activity the art of keeping unobserved is paramount as the naturalness of the scene will be lost if you are discovered.

▶ First stage

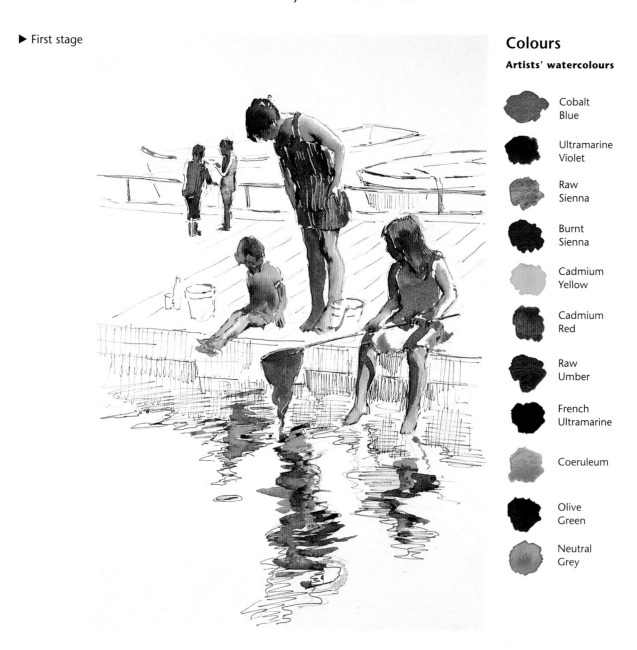

Colours

Artists' watercolours

Cobalt Blue

Ultramarine Violet

Raw Sienna

Burnt Sienna

Cadmium Yellow

Cadmium Red

Raw Umber

French Ultramarine

Coeruleum

Olive Green

Neutral Grey

First Stage

I sketched in the main features with pencil, balancing the tall figure with the two children seated either side. I sketched in the background boats, children and reflections using a water-soluble sepia pen, depositing more ink in thicker lines around the areas I needed to be darker and more pronounced. I then applied masking fluid to the highlighted features, such as the tops of the heads, fishing net and some of the clothing.

Using watercolours, I painted in the figures, using Burnt Sienna washes for the skin colouring, Cobalt Blue for the striped shorts and top, Ultramarine Violet for the child holding the fishing net, and Cadmium Yellow for the smallest child. I added flashes of the same colours to the water reflections, keeping it loose. I tried to keep the water looking 'active' by using zigzag movements, mirroring the figures above and even exaggerating their length to give a more watery feel. I then darkened the features of the children using a little more Burnt Sienna for the shaded areas.

Second Stage

I needed a loose background, so added water, then a little wet-into-wet Coeruleum, which made the water-soluble ink run and gave different gentle effects. I then added a little Cobalt Blue and Ultramarine Violet, especially into the boat shapes, but kept it all understated. I repeated the wetting of the paper for the jetty and reflections, letting it diffuse and run together with the ink and mixed in a little Burnt Sienna. Dark Olive Green was painted into the jetty, and zigzagged delightfully into the reflections. This added a good contrast as the brighter the sunshine the darker the shaded areas.

The legs of the seated child need to be emphasized, so I used French Ultramarine and Burnt Sienna to darken the side of the jetty and the lapping water to highlight this feature. A little more Olive Green and French Ultramarine was used to darken the jetty further to gain even more contrast.

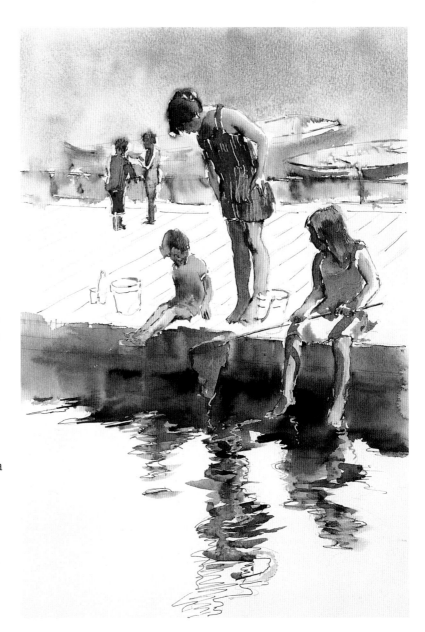

▲ Second stage

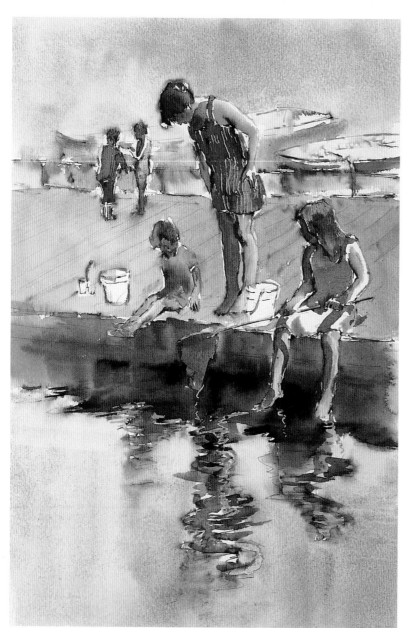

Finished Stage

To suggest more colour I used Cadmium Red for the bucket, adding slithers into the reflections, and repeated this method for the other bucket in Olive Green.

The sea needed a little more movement and action, so I offered small stabbing marks of Coeruleum, using a size 5 round-headed brush, to give deeper waves. When all the paint was dry I rubbed off the masking fluid with my fingers. I then added pastel colours, using the colours already in the immediate areas, so that the light colours are obvious, but not glaring.

Shadows throughout the picture were then needed. I mixed Cobalt Blue, Ultramarine Violet and a little Burnt Sienna and placed in washes to link the children, the foreground and under the feet of the background figures. Finally, I slightly defined the children's faces.

Third Stage

The soft diffused colours from the water-soluble ink were encouraged with a wetting of the paper over the sea area, plus a wash of Coeruleum with broad vertical brush strokes to capture the gentle undulations of the water. I used a mix of Neutral Grey and Burnt Sienna for the decking. This covered the last of the white paper and helped with placing the last tonal areas.

▲ Third stage

► **Children Crabbing**
39 x 27 cm (15½ x 10½ in)

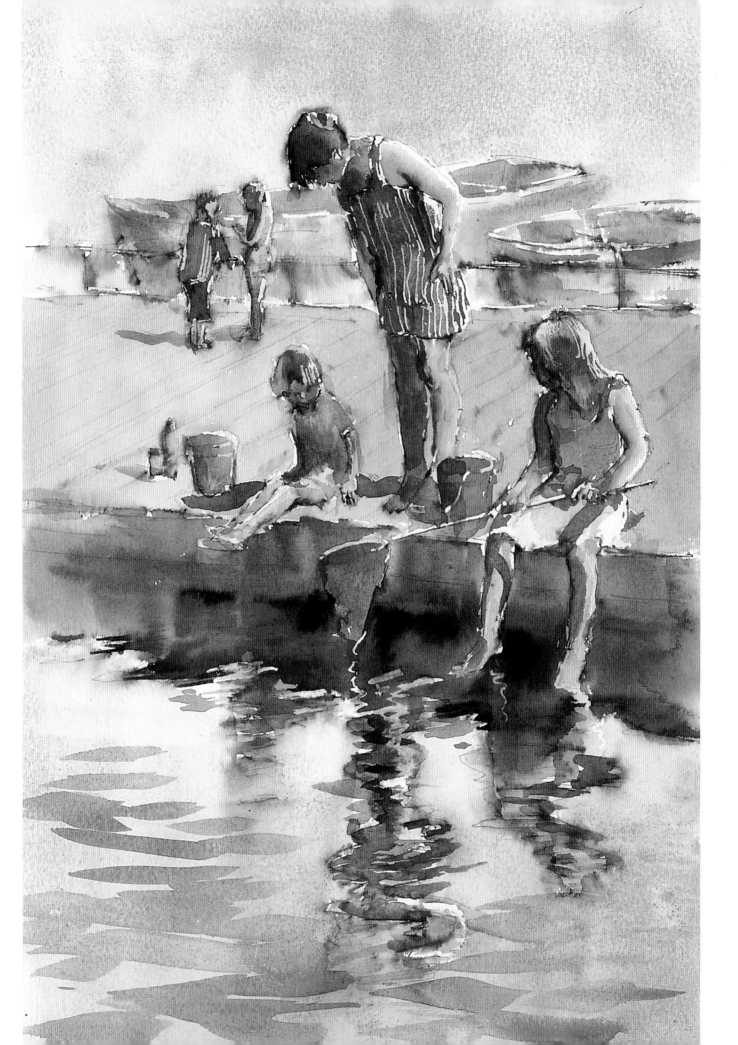

Sunflowers

These glorious sunflowers are perfect for exploring blazes of vibrant coloured inks. A mixture of acrylic, drawing and calligraphy inks provides an opportunity to 'go' for colour and contrast, using several techniques in the same picture. Exciting swathes of ink colours can be used equally well for anemones and poppies.

▶ First stage

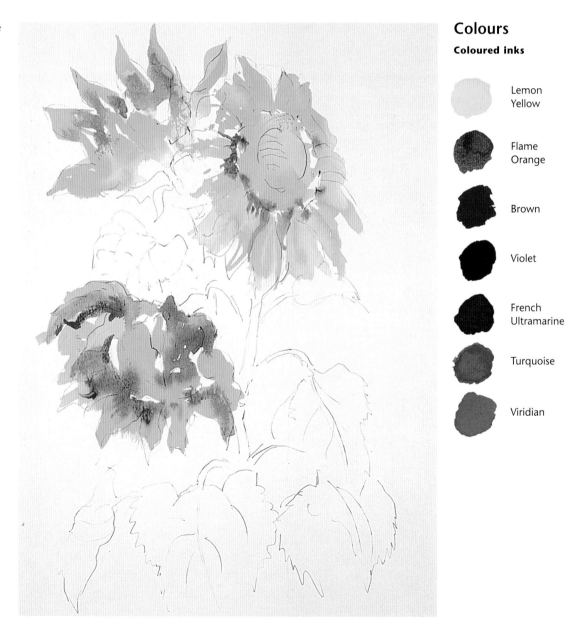

Colours

Coloured inks

Lemon Yellow

Flame Orange

Brown

Violet

French Ultramarine

Turquoise

Viridian

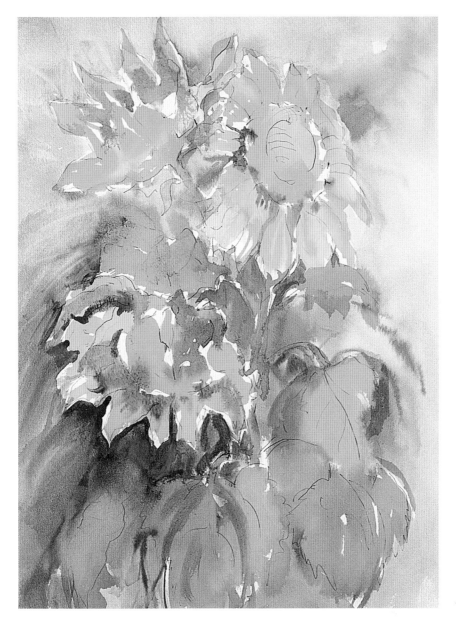

◄ Second stage

First Stage

I drew in the sunflowers in assorted positions using a soft pencil. Using Lemon Yellow ink in a watery wash, I started to paint in the flower heads, connecting them with a flow of colour, with a little orange dropped in. Brown was painted into the shadow areas of the leaves, using a large size 10 flat-headed brush. For the smaller details I used a size 5 round-headed brush. I applied a soft yellow underwash into the centres of the flowers to add warmth and glow.

I then had to decide where to place the focal point, which would hold the darkest, lightest and brightest colours.

Second Stage

I chose a Violet and French Ultramarine mixture to place into the background, highlighting this area, and wetted the paper well before doing so. I placed in some of the underwash of leaves and painted in some negative shapes to create depth and interest.

Wetting around some of the flower petals, I used a larger brush to place Turquoise and Violet washes into the background, emphasizing the focal point. Using a size 1 rigger brush, I added this mixture between and round the flower edges. With a delicate mixture of Viridian and Lemon Yellow I added more underwash on the leaves.

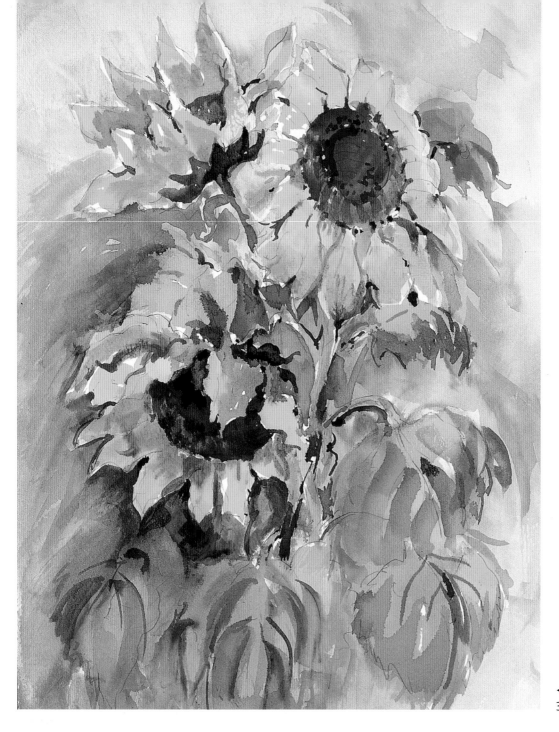

◀ **Sunflowers**
39 x 30 cm (15½ x 12 in)

Finished Stage

The picture now had to be more cohesive. I continued to accent the negative shapes with a violet/blue mixture, giving a shadowed feel to the leaves. They needed to overlap, with some in the shade and others highlighted in sunshine. The centres were a mixture of Violet and Viridian – areas of bright colour were dabbed back with kitchen roll and details painted with Brown and Violet with a size 1 rigger. Using the same brush I added veins to the leaves and outlined some of their edges, so giving the illusion of one being in front of another. I glazed orange onto the back flower to make it more pronounced, and a little more yellow into the mixture to dot over the leaves to bind the picture together. A wash of Turquoise was added to the right side of the flowers to add contrast and zest.

I rounded some of the foliage between the veins and edges with broad brush strokes. I then worked with flecks of dark ink to highlight the petals further. I wetted some of the centres of the petals and dropped in Flame Orange to bring the heads forward.